CHE GUEVARA: REVOLUTIONARY & ICON

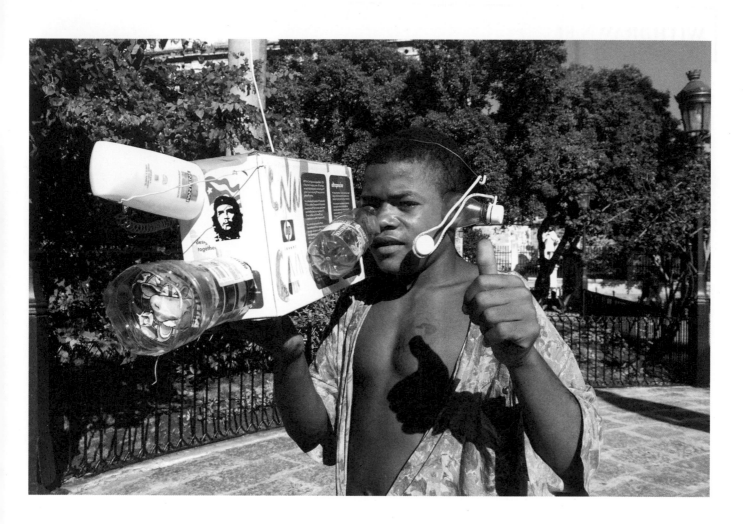

Julio, Lucas, Pablo and Maemae; Charlie and baby Max; Mario,
Dylan and Alejandro; Jimena and Emilia; Isabel and Ines;
Maddy and Daphne; Michelle, Nicole and Andrea; Ali, Joey,
Ben Z and Ana; Daniel, Ted, Chase, Max S; Duncan and Cormac;
Camila; Diego and Matías.

To my son Julio hovering on the edge of adolescence and to my
godson Ben now a man and a father and all the children in the
world of our extended family, whose lives I am fortunate enough
to witness and enjoy, who make it worthwhile. For you all.

CHE GUEVARA: REVOLUTIONARY & ICON

EDITED BY TRISHA ZIFF

V&A PUBLICATIONS

First published in 2006 by
V&A Publications
Victoria and Albert Museum
Cromwell Road
London SW7 2RL

ISBN 10: 1 85177 4955
ISBN 13: 9781851774951

A catalogue record for this book is
available from the British Library

The accompanying exhibition
was organized by UCR/California
Museum of Photography,
University of California,
Riverside. It was made possible
with the additional support of the
Anglo Mexican Foundation,
Center for the Study of Political
Graphics, Los Angeles
(www.politicalgraphics.org), and
Zonezero

Front cover design:
Nick Bell design
Back cover image:
Che Guevara. Photographed
by Alberto Korda, 1960,
Havana, Cuba. Courtesy of the
Korda Estate
Frontispiece:
Untitled, 2002. Jordi Dulsat, Cuba.
Courtesy of the photographer

Designed and typeset by
Nick Bell design
Printed in China

With thanks to David Kunzle whose scholarship and generosity this book is built upon.

INTRODUCTION Hannah Charlton

Walk through any major metropolis around the globe and it is likely that you will come across an image of Che Guevara – the Korda image of Che, that is, the face of '*Guerrillero Heroico*' tilted up towards some vision of the future, with his beret, tangle of locks and intense, soulful gaze that crosses cultures and time. The image may be stencilled on a wall, integrated into graffiti, reproduced on a mug or hat, or most likely screen-printed on a T-shirt and worn by anyone aged from eight to eighty.

The fact is that in our global culture, with its proliferation of images beamed at us from televisions and mobile phones, this single image of a face may be the most reproduced image in the history of photo-graphy. It has been endlessly mutated, transformed and morphed – and as such tells the history of the last forty years of visual, popular culture.

Possibly more than the Mona Lisa, more than images of Christ, more than comparable icons such as the Beatles or Monroe, this image has continued to hold the imagination of generation after generation. It has been transformed from revolutionary legend to an ingredient in global marketing, to a generic, high-street visual emblem for a vague notion of dissent, rebellion and political awareness, as well as becoming the subject of kitsch and spoof makeovers. Why? Part of the answer is that the image, as icon, has discarded the

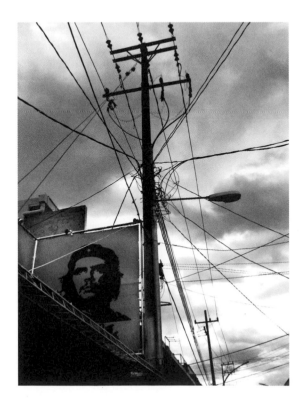

Untitled, 2003.
Raúl Ortega,
Culiacán, Sinaloa,
Mexico. Courtesy
of the photographer.
(See page 63)

specific details of Guevara's achievements and taken on a life of its own, as a potent symbol of freedom, of anti-establishment for a new generation that has embraced the idealism of the young Che of *The Motorcycle Diaries* film.

The complex layering of cultural and social meaning associated with the many versions and manifestations of the image makes the journey from black and white 35mm image to eBay merchandising peculiarly fascinating and unique. A recent sighting of a six-year-old boy wearing a T-shirt with the Che image surrounded by the slogan 'Viva Walthamstow' offers various readings: Latin pride? Breakaway borough? Ironic statement? Or just a well-intentioned mixing of image and message? Ask Che T-shirt wearers who he is and answers will range from freedom fighter to idealist hero. Few will know his name, origins and life story – they might wear his

face as an easy replacement for real activism or as a surrogate for it. Some even think he may be one of the young, dead idols like Kurt Cobain or Jim Morrison. For many Che has metamorphed from man to nameless icon.

The story of the evolution of this image starts with the man himself: Ernesto 'Che' Guevara. Born in Argentina in 1928, the young medical student made a journey of discovery around Latin America that inspired his desire to unite and liberate the poor of the world. In 1956 he joined Fidel Castro on the memorable journey across the sea from Mexico to Cuba to overthrow the dictator Fulgencio Batista; in the ensuing struggle he fought with such apparent courage that he earned the title of Comandante. After holding key posts in Castro's new socialist Cuba, he left Castro in charge, to pursue his vision of liberation in the Congo and in Latin America. In 1965

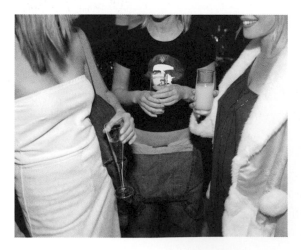

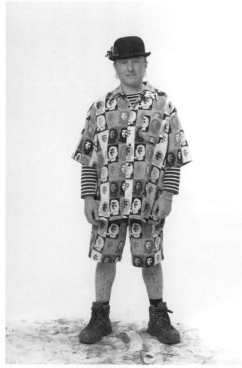

he resurfaced in Bolivia, where he was captured and assassinated near Vallegrande on 9 October 1967.

The now-famous photograph of Che dead, laid out as a Christ figure, taken by Freddy Alborta, was circulated around the world and magnified his mythical status. This was assisted by his charisma and youth, the supposed CIA involvement in his death and the fervency of the response around Latin America – 'We won't let him be forgotten'. But the enduring image is the one taken in 1960 by Alberto Korda, of Che defiant and very much alive. Indeed, while the 'Guerrillero Heroico' has never been forgotten, Che's individual destiny has mutated into something both greater and yet far from what he intended. The true bravery and generosity of the man, as well as the shadows surrounding some of his later actions – his brusque prison sentences – have for many been eclipsed by T-shirts with a stylish symbol of resistance, protest and desire for change, used for a spectrum of anti-war, anti-world debt and anti-Americanism, as well as individual liberation and human rights movements. Che's face spans the globe – and all causes.

The image itself has a clear genesis. Korda, a Cuban fashion photographer who had become Fidel's personal photographer, was attending a funeral service for the Cubans killed during a counter-revolutionary attack in March 1960. Guevara stepped forward onto the memorial service podium for a brief appearance, and in a moment of inspiration Korda caught something in the bearing and expression of Che and shot two frames. The intensity of Che's gaze is apparently to do with his extreme frustration (Korda later referred to Che as looking *encabronado y dolente* – angry and

pained), but Korda isolated the figure of Che from the original frame, in which Che stands between a man and palm fronds, and thus the icon was born.

There are conflicting reports of the progress of the image. Korda, himself recognizing the quality of the image, pinned it on his studio wall, and over the years gave it to Che admirers. One of these admirers included the left-wing Italian publisher Feltrinelli, to whom Korda gave a print just before Che's death in 1967, and who reproduced it as a poster in honour of the dead man. Suddenly, Che was everywhere.

Immediately after the news of Che's assassination by the Bolivian police at the age of thirty-nine had been flashed around the world, Che, already a figure of mythical status in Latin America, was elevated to the status of martyr and his legendary status evolved. In the turbulent political climate of the late 1960s his image graced

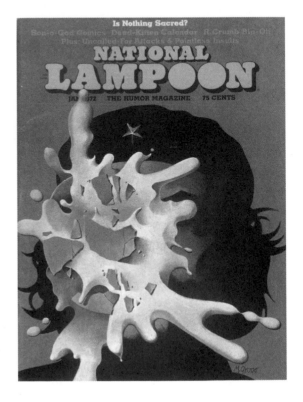

Far left: **Opening of the Saatchi Gallery, housed in the Former County Hall, London, 15 April 2003. Martin Parr, UK. Magnum Photos. (See page 109)**
Left: ***Pinball Jerry, Glastonbury*, 2005. Barry Lewis. Courtesy of the photographer. (See page 81)**
Right: ***National Lampoon*, vol. 1, no. 22, January 1972. Published in New York. Collection of Trisha Ziff. (See page 118)**

all manner of political posters, banners and badges. Once the photographic face had been transformed to the silk-screen image, the door was open for designers and artists to gleefully adapt every form of Pop style and recreate him in their own version. From psychedelic swirls and colours to basic geometric lines, Che was lovingly and respectfully given every form of visual makeover. In agit-prop and satirical magazines and posters, his face, whether full page or tucked away as a detail or background, was an essential element in political messaging.

The next chapter in Che's transformation was his adoption as a style icon. In the marketing arena of the early nineties, the baby boomers who as students painstakingly painted giant Che images onto their walls, or at the very least pinned the ubiquitous poster there, were shunted aside for the new youth audience. Emerging mega brands such as Nike, Hilfiger and Reebok were working hard to capture and reflect back the pluralistic values and identities of their younger audiences, and therefore incorporating a much fuller range of diversity (sexual, racial, cultural, social and political) into global messages. They dug deep into teenage activities to find what was hip and cool, synthesizing it and returning it in branded lifestyle choices to create must-have consumer goods. This all created the context in which the aura of a revolutionary figure such as Che could be used to give value and cachet to everyday goods.

By the late nineties the global market saw the emergence of what Naomi Klein has called a 'market marsala' – a bilingual mix of North and South, some Latin, some R&B, all couched in global party lyrics.

By embodying corporate identities that are radically individualistic and perpetually new, the brands attempt to inoculate themselves against accusations that they are in fact selling sameness. The next stage is to present consumption as a game or code, where mega brands, reflecting the very 'indie' values of their audience, can do so with a knowing irony that of course the wearer/user can remain seemingly untouched by the corporate values underpinning the transaction. Enter Che: the symbol of student revolution can be used to add allure to a product, because an increasingly sophisticated audience is smart enough to distinguish between revolution and commerce and to enjoy the irony. Che now begins the metamorphosis from political symbol to a paradoxical position in the global corporate culture. The commodification of the image has truly begun.

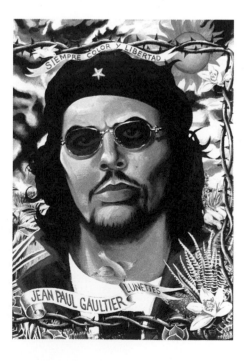

In an advertisement for Jean Paul Gaultier sunglasses circulated in Europe in 1999, Che is painted in a Frida Kahlo-type landscape, all rich cacti flowers and blazing desert sun. Che himself is framed in spiky thorns reminiscent of Christ, and in a direct lift from socialist banner styles the slogans above and below the face proclaim, in a breathtakingly bravura style, recalling Che's original slogan, '*Hasta la victoria siempre*' – '*Siempre color y libertad*' and 'Jean Paul Gaultier Lunettes'. There is a dove of peace at Che's neck and blue Gaultier shades covering the resolute gaze of the man who vowed to free the poor of the earth.

Again in 2000, the Che image was used to promote Smirnoff Vodka with the slogan 'Hot and Fiery' – familiar stereotypical concepts for Latin lovers and revolutionaries. In fact Korda, who has never received anything for the widespread use of his image, sued Smirnoff for usage in this UK campaign and donated the resulting out-of-court settlement of £50,000 to the Cuban medical system.

Leica take a grainy version of the black and white image, insert a red star and refer to their revolutionary camera. Magnum Ice Cream in Australia neatly juxtapose the face of Che next to the word 'Force', and play on his name with the flavour 'Cherry Guevara', as though the Cuban icon would build an aura around the five-minute experience of eating an ice cream. And in the best tradition of homage, there have been spoof versions of Che sporting the Nike swoosh in place of his high-status star.

Appropriating the aura of Che for brand building has now given rise to a new resurgence of Che-ness that transcends branding in its global appeal. In the shifting complexities of intercultural values, in the search for universal images that can speak across borders and boundaries, today's

Left: **Sunglasses advertisement, 1999. Jean Paul Gaultier, Paris.** (See page 120)
Right: **Smirnoff Vodka advertisement, 2000. Collection of David Kunzle.** (See page 121)
Far right: **Che Nike**, date unknown. *San Francisco Bay Guardian*, March 1993. Collection of David Kunzle. (See page 118)

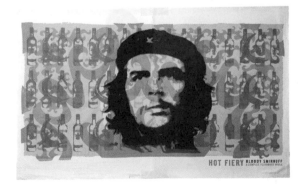

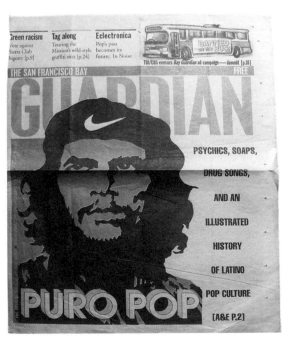

global image of Che is the most successful. The Che face, more than any other icon, can keep accruing new application without relinquishing its essence – a generic and positive version of anti-status quo and liberation from any oppressive force, and a general, romantic, non-specific fantasy about change and revolution. It emerges in Vietnam, and in China – finding its place among a wealth of Maoist memorabilia. Che connects the wearer to a desirable spectrum of cool but caring attitudes that are instantly recognizable but above all not connected to any brand. When the Osbourne family is photographed by Annie Leibowitz in the bathroom of a hotel, as an alternative to the standard 'At home', son Jack is wearing a Che T-shirt. Stylists regularly use Che for added cred – as, for example, in a recent episode of the British soap opera *Hollyoaks*. When British comedy and TV star Ricky Gervais (of

The Office series fame) brought out a DVD of his *Politics* live stand-up show in the autumn of 2004, he chose to represent himself on the cover as Che.

With any other image, its mass presence and sheer familiarity would mean a dilution of meaning. But in the case of Che, there is the possibility of endless visual mutation, of stylistic regeneration without ever losing the essence of what the face expresses. Whether painted, caricatured or crudely drawn on walls, the very simple qualities of the hair, beret, dark eyes and mouth come through as an archetype that cannot now be totally distorted.

The artist's response has been to comment on the commodification of the image. Thus Pedro Meyer's image of Che transposed onto the 3-dollar bill is an exploration of the values at the heart of the dollar currency. It also is a knowing reference to the Cuban pesos note on which Che, as a key figure in the Cuban administration, was used as the central image. And Warhol – the master of mass iconography – would have enjoyed the twist that most people assume that the multicoloured nine-panel version of Che, attributed to him, is the 'real' thing whereas in fact it is a fake. Latin artists have shown Che transposed with Christ on the Cross, with Contra soldiers on the right and Latin American peasant women in the place of the Mary. In another painting, Che is in Christ's position at the Last Supper, framed by Aztec/Mayan columns and surrounded by famous Latin American and Mexican figures, under the watchful eye of the Virgin of Guadalupe. In Latino culture, Christ and Che mingle together, although Che himself was vehemently opposed to any parallel: 'I am the very opposite of Christ....I will fight

with all the arms within reach instead of letting myself be nailed to a cross', he wrote to his mother from a Mexican jail in 1956.

Icons breed icons, so there are the Osama Che, the Palestinian Che and even the Princess Di-Che – all faces that have been morphed or transposed to blend the features of both into a single new icon. This is all part of popular culture, where images can be manipulated, blogged and circulated in a way that was not possible before. The chief commodification has been with merchandising, Disney style: choice abounds in kitsch banality, as a visit to eBay will reveal.

The recent film *The Motorcycle Diaries* stimulated a resurgence of interest both in Che and in the countries he travelled through, including Cuba, where there is now an activity holiday called the Che Trail that follows his revolutionary journey. The film remains resolutely with the young idealistic Che in the first throes of forming his vision of a fairer world. His friend Alberto Granados, who travelled with him and has subsequently spent the rest of his life working as a professor of biochemistry in Cuba, is philosophical about what has happened to his friend Ernesto. In her film *My Best Friend*, when producer Clare Lewins asked Alberto what he considered to be the reason for Che's continuing attraction, his response was: 'Because he was a man who fought and died for what he thought was fair, so for young people, he is a man who needs to be followed. And as time goes by and countries are governed by increasingly corrupt people… Che's persona gets bigger and greater, and he becomes a man to imitate. He is not a god who needs to be praised or anything like that, just a man whose example we can follow, in always giving our best in everything we do. That's what keeps you always young.'

Left: *The Osbournes: Kelly, Ozzy, Sharon, and Jack Osbourne.* The Beverly Hills Hotel, California, 7 October 2002. Annie Leibovitz for *Vanity Fair*. Courtesy of Contact Press Images. (See page 107)
Right: *Last Supper of Chicano Heroes*, 1989. José Antonio Burciaga and Ed Souza, US. Reproduction of an 8 x 15-metre mural at Stanford University, California. Offset print. Center for the Study of Political Graphics, Los Angeles. (See page 94)
Far right: **Che lookalike, taken from the web.** Courtesy Jonathan Green, California Museum of Photography, UC Riverside, CA. (See page 84)

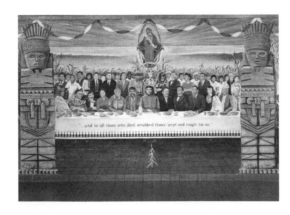

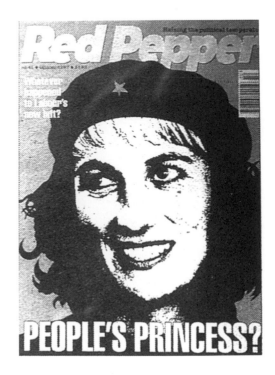

The story of the Che image is in part the story of the growth of visual literacy, in a global culture of images that speak across borders, interests and languages. The familiar image can be customized to suit any individual, any protest, and can disseminate a message that is instantly recognizable and has an ever-potent visual currency. If Che's image is used in any way – whether on a poster, T-shirt or mug – to support the growth of a more cohesive world, then his individual destiny has merged with historic forces in ways he could never have imagined.

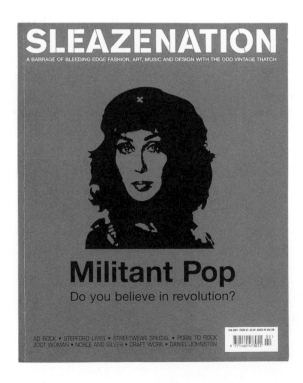

Sleazenation,
February 2001. 'Cher Guevara'. Illustration: Scott King. (See page 85)

GUERRILLERO HEROICO Trisha Ziff

The portrait of Ernesto 'Che' Guevara by Alberto 'Korda' Díaz (1928–2001) was taken on 5 March 1960. The day before a French freighter, *Le Coubre*, had exploded in Havana harbour, killing more than eighty Cubans; it was carrying over seventy tonnes of Belgium ammunition destined for the revolution. Outraged, and convinced that this was the work of the CIA, President Fidel Castro called for a mass funeral at Havana's Colón Cemetery where, facing a sea of thousands of people, he gave his oration from a platform that included visiting French intellectuals Simone de Beauvoir and Jean Paul Sartre.

Among the crowds was Korda, Fidel's personal photographer. Before the revolu-tion he had been a fashion photographer, so it was no accident that with his history and his eye for beauty he saw in this moment the enigmatic gaze that captured Che's charisma. Interviewed many times about the photograph, Korda described Che at that moment as *encabronado y dolente* (angry and pained). He snapped two frames with his Leica camera before Guevara disappeared from view.

Korda had been on assignment for the Cuban daily newspaper *Revolución*, although the image was not included in the following day's report. Noting the image on his contact sheet, Korda made a small print for himself, a cropped portrait, and pinned it casually on his studio wall, where

Right: **Korda's Che was first published on 16 April 1961 in Cuba in the daily newspaper** *Revolución*. **The conference the image advertised was disrupted by the events of that day: the invasion of the Bay of Pigs. The image was republished a second time** (far right) **advertising the newly convened conference on 28 April 1961. (See page 41)**

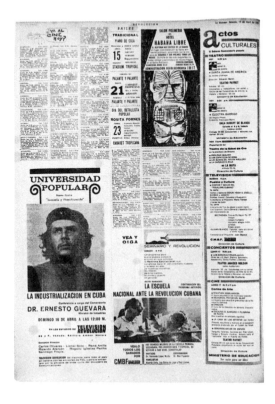

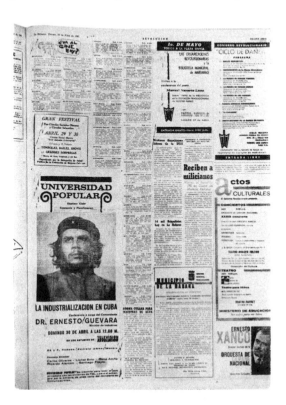

it remained for years. Many visitors passed through his studio and saw the print, but it is not known how many copies Korda made or gave away to either international visitors or friends – prints that could possibly have contributed to its early dissemination.

Revolución first published the portrait a year later, when it was used to promote a conference during which the Minister of Industry, Dr Ernesto 'Che' Guevara, was to be the main speaker. Scheduled for 16 April 1961 at noon, the conference was disrupted when 1,300 CIA-supported counter-revolutionaries stormed the beaches of Cuba in what would be a failed invasion, which became known as the Bay of Pigs. Che immediately left with others to defend his country. On 28 April a second, similar advertisement reusing the image appeared in the paper, announcing the rescheduling of the conference for 30 April 1961. It seems very likely that in the context of both

these publications, Che would have seen the photograph that would later contribute to his iconic status.

The phrase 'Copyright Libreria de Feltrinelli' was to become a source of contention for Alberto Korda. Gian-Giacomo Feltrinelli, a wealthy Italian intellectual and publisher as well as an admirer of the Cuban Revolution, had himself resigned from the communist party when pressured not to publish Pasternak's *Doctor Zhivago* (having personally smuggled the work out of Russia in 1957). As his publishing house grew, Feltrinelli gained a cutting-edge reputation for publishing important works by prestigious contemporary authors and radical thinkers. In 1964, Feltrinelli visited Cuba with a journalist colleague, Valerio Riva. They had hoped to publish a book by Castro on the revolution, but this project never came to fruition. Feltrinelli returned a second time to Cuba from Bolivia in 1967.

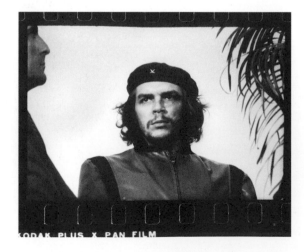

He had travelled to Bogota to intercede in the release of French intellectual Regis Debray, who had been with Che Guevara before his arrest by the Bolivian military. Feltrinelli, understanding the gravity of the situation and the high level of CIA activity, might well have come to the conclusion that Che Guevara's days were numbered.

While in Cuba, Feltrinelli visited Korda's studio and was given two gift prints of the cropped image by the photographer. Perhaps motivated by the desire to bring attention to the danger that Che was in, he published and disseminated thousands of copies of the poster free on his return to Italy.

Feltrinelli's son Carlo recalls that the image was published before Che's death with the idea of 'protecting' Che through international awareness of his vulnerability and not – as until recently historians of the image believed – that it was produced in response to the news of Che's murder. In the lower left corner of the poster there is an inscription that reads 'Copyright © Libreria Feltrinelli 1967' with no reference to the photographer, a practice that would have been commonplace at that time.

Soon after, Feltrinelli published Régis Debray's *Revolution in the Revolution* (1967) while Debray was still held in a Bolivian jail, and the following year (1968) he published Che's *Bolivian Diaries*, having obtained the worldwide copyright for the book. The Korda Che image appeared on the book cover and on posters promoting the book, and it was shown at that year's Frankfurt Bookfair in the month that Che was murdered. It is unclear exactly how Feltrinelli got access to the diaries, although it is known that Antonio Arguedas, a Bolivian general (who later became a supporter of the Cuban Revolution), had also guarded the severed hands of Che and his death mask; he was responsible for the book being smuggled to Cuba.

The following year, 1968, was an extraordinary year for the Feltrinelli publishing house, with major works appearing in print such as *One Hundred Years of Solitude* by Gabriel García Márquez; Louis Althusser's *Leggere il capitale*; Herbert Marcuse's *Critic of the Repressive Society* and R.D. Laing's *Politics of Experience*. Feltrinelli the publishers had become a bastion of radical thought and of the new avant-garde writers of the late sixties. Feltrinelli died soon after in 1972, under somewhat extreme circumstances. Various theories surrounded his death, including suicide and that he was the victim of a fascist assassination. However, it appears that he accidentally blew himself up while engaged in planting a bomb outside Milan.

Left: *Guerrillero Heroico* by Alberto Korda, March 1960, Havana, Cuba. Courtesy of the Korda Estate. (See pages 38–9)
Right: *Comandante Ernesto 'Che' Guevara*, Feltrinelli, 1967. (See page 40)

The image of *Guerrillero Heroico* continued to gain momentum as an icon, symbolizing the political struggles of the left to a world of designer radical chic, increasingly removed from the man Ernesto Guevara to a new meaning devoid of its original context, disregarding the specificity its own history and emerging with its own contemporary resonance.

From gable ends in Belfast to Soweto, Korda was often proud that his photograph was reproduced. By the nineties, however, his own awareness of the nature of his image had changed, and he began to make references in interviews to the fact that he had not been paid by the publishing house of Feltrinelli, who, he argued, had become wealthy as a result of sales of the original poster. Gian-Giacomo's son Carlo wrote in his biography of his father that Feltrinelli printed 'thousands' of copies of what he refers to as the 'Che in the sky with jacket'

poster and had them hung in his numerous bookstores throughout Italy for no other reason than to respect the memory of the revolutionary. Korda, on the other hand, believed that the posters were sold, and often reflected in interviews that if he had requested a percentage on the sales from the poster he would have become a millionaire.

In a personal letter, confirmed in an interview in Milan in May 2005, Carlo Feltrinelli told historian David Kunzle that the poster was made 'with no lucrative intention'. Feltrinelli's political integrity is beyond dispute. In the Italian edition of Che's *Bolivian Diaries*, which bears the Korda photograph, it states: 'The proceeds of this publication will be donated entirely to the revolutionary movements of Latin America'. He certainly did not need to sell posters, but other political groups might well have sold them to raise their own funds, and Korda was responding to information on sales of his posters without possibly knowing the circumstance in which these sales occurred. Today, those close to Korda still blame Feltrinelli, and complain not only that Korda's name was missing from the poster, but also that the author of the photograph never even got a sample poster – any more than he got from the Cuban government a sample of the Cuban banknote with the Korda-derived image on it. There was never any communication from Feltrinelli in the years up to his death in 1972, or from his publishing house since then.

Until the recent discovery of the article about Che Guevara in the July 1967 issue of *Paris Match*, it was assumed that *Guerrillero Heroico* was not reproduced in Europe until the time of Che's death in

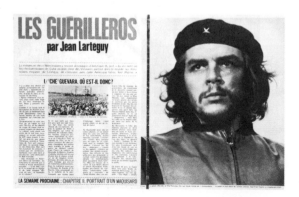

Milan. However, this issue of *Paris Match* was published earlier, just a few weeks before the revolutionary was captured and put to death. The issue featured a major article, 'Les Guérilleros' by journalist Jean Lartéguy, author of the novel *Mercenaires*, who the magazine described as 'recently back from guerilla-controlled areas in South America'. Lartéguy wrote: 'At a time when Cuban revolutionaries want to create Vietnams all over the world, the Americans run the risk of finding their own Algeria in Latin America.' Lartéguy then asked: 'Where is Che Guevara?' The article reproduced Korda's photograph with the following caption: 'The official photograph of Che Guevara; on his beret the star, the symbol of Commandante. A high position in the Cuban army; only Fidel Castro held a position of more importance.' It is not known who provided the magazine with the photograph, and it is also not credited to

Feltrinelli. With its large circulation beyond France and its influence in Europe at that time as an important news journal, this issue of *Paris Match* was clearly responsible for the image being seen and disseminated for the first time not only in France, but also to a wide European audience.

The very first time Cubans became familiar with the photograph, despite its earlier reproduction in *Revolución*, was on hearing the news of Che's murder, when it was enlarged and draped on a banner down the five-storey building of the Ministry of the Interior in the Plaza de la Revolución in Havana, as a backdrop to Fidel's speech of 18 October 1967 acknowledging the death of Che. Since then the building has seen many versions of the Korda Che. Today, a permanent steel outline derived from the photograph adorns the building.

Frémez (José Gómez Fresquet), renowned Cuban poster maker and graphic

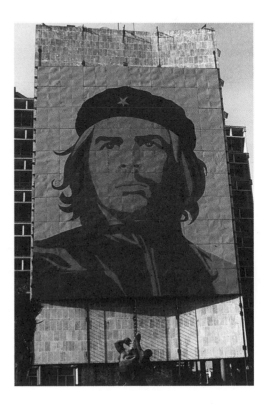

Left: **'Les Guérilleros', article by journalist Jean Lartéguy.** *Paris Match***, August 1967. (See page 41)** Right: **Ministry of Interior Building, Plaza de la Revolución, Havana, Cuba.**

artist, recalled how on hearing the news of Guevara's death he worked all night producing the poster to be used at the rally honouring Che, held in Plaza de la Revolución on 18 October. Korda had given Frémez a copy of the portrait as a basis for the poster. Using the printing press of the Consejo Nacional de Cultura, Frémez recalls that he could barely believe the news, and attributed the 'faint dots of the screen appearing and reappearing' as symbolic. There was no time to use more than one colour for the poster and only red paper was available. This was the first spontaneous and privately produced image using the Korda Che to be produced in Cuba.

The first official poster to be commissioned by the Cuban state to commemorate the death of Che was produced by Niko (Antonio Pérez González), a graduate of the University of Havana. Niko studied at ICAIC in 1968 and designed posters for Cuban and international film, as well as political posters for revolutionary campaigns of the 1960s and '70s. This was one of his first and most influential works.

Irish artist Jim Fitzpatrick states that he too produced a graphic piece based on the Korda image before Che was murdered. At the time he had no idea who had taken the photograph. Fitzpatrick would print about a hundred copies of his posters at a time to fulfill the demand of political groups asking for the image from within Ireland, Spain, France and Holland. His own fascination with Guevara stemmed both from his respect for the rebel, who reminded him of the protagonists of the 1916 uprising in Ireland, and from having once met Che when he had visited County Claire while travelling in Ireland from Cuba en route to the Soviet Union. Guevara, like many Argentineans, claimed Irish heritage: his grandmother Ana Isabel Lynch's family

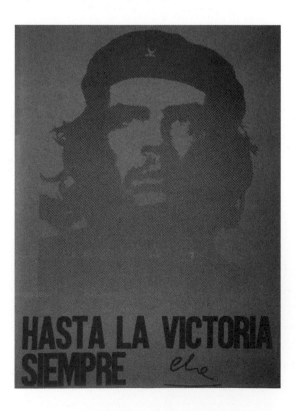

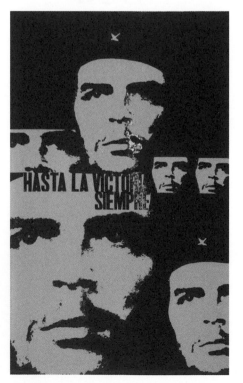

had come originally from County Galway during the Irish Famine to settle in Argentina. Not forgetting their Irish heritage, Che's family had always referred to themselves as the Guevara Lynchs.

Fitzpatrick recalls that he possibly received a copy of the photograph in 1967 from a Dutch anarchist group who produced the magazine *Provo*. The Provos originated in the Second Situationist International in 1961; they were the inspiration of Roel Van Duyn, a window cleaner and performance artist close to Jean Paul Sartre. Fitzpatrick remains adamant that his source material was not Feltrinelli and that his own poster was the first to be produced in Europe before Che's death, before the Feltrinelli poster.

This could be the case; we know for sure Sartre was present at the funeral at Colón Cemetery and that he travelled into the Cuban interior during his visit to Santiago de Cuba with Simone de Beauvoir, Castro and Korda all in the same car. It is possible that Korda gave a copy of the portrait to Sartre. However, Korda's daughter Diana Díaz does not recall her father mentioning this and neither does his colleague José Figueroa, who printed most of the images for Korda. Figueroa says the trip with Sartre was very hurried and most probably Korda did not have the time to present him with the photograph, although Korda had given Sartre a print of his portrait.

Fitzpatrick produced a variety of posters in 1967–8 using the Korda Che; the best known was printed on silver foil and was exhibited in an exhibition in London called 'Viva Che' at the Arts Laboratory in the spring of 1968. It was curated by Peter Mayer, originally for the Lisson Gallery, and illustrates how fast the image moved from the language of protest into the fine art gallery. Included in the show were other Che works by Fitzpatrick, as well as a large oil painting, now lost.

It was not until 1986 that José Figueroa, an established Cuban photographer and close friend and printer for Korda, produced the first full-frame print from the negative. Korda continued to print both versions until his death in 2001.

Smirnoff Vodka used the Korda Che image in an advertising campaign in 2000 for the London Underground. Korda sued Smirnoff for copyright abuse and won an out-of-court settlement of $50,000. Commenting on the suit in the *Christian Science Monitor* on 5 March 2004, Korda said: 'As a supporter of the ideals for which Che Guevara died, I am not averse to its reproduction by those who wish to propagate his memory and the cause of social justice throughout the world, but I

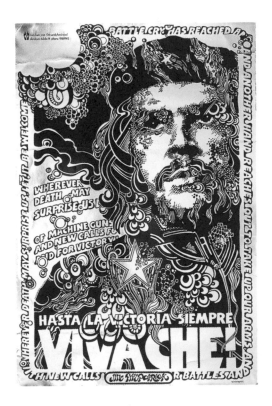

Far left: *Hasta La Victoria Siempre*, October 1967. Frémez (José Gómez Fresquet), Havana, Cuba. 59.5 x 44.5 cm. (See page 43)
Left: *Hasta La Victoria Siempre*. Niko (Antonio Pérez González), Cuba. 98 x 54.5 cm. First publicly produced poster of Che, October 1967. Reproduced for the ninth anniversary of the death of Che Guevara. Center for the Study of Political Graphics, Los Angeles.
Right: *Viva Che*, 1968. Jim Fitzpatrick, Ireland. Screenprint on foil. 75.5 x 50 cm. (See page 45)

am categorically against the exploitation of Che's image for the promotion of products such as alcohol, or for any purpose that denigrates the reputation of Che.'

It was not until 1968 that the image first appeared in the USA, inspired by a painting by Paul Davis and adapted by Kenneth Dearoff, the designer for the cover and poster advertising the *Evergreen Review* (February 1968). Davis recalls that he was inspired by Italian paintings of martyred saints and Christ in his romanticized version of the suffering Che. Formatted to fit New York subway billboards, the posters were systematically defaced, and a bomb was tossed into the *Evergreen Review* offices.

Guerrillero Heroico is considered to be the most reproduced image in the history of photography. Whether this claim can be substantiated or not, Korda's Che is nonetheless a unique image. It has come to symbolize anti-establishment radical thought and action, sustaining its currency from events such as the Prague Spring to the present conflicts in the Middle East and radical guerilla movements in Latin America, reverberating from the Cold War to our post-colonial reality. It is an image that has inspired contemporary art as well as commerce; it has been mimicked by superstars and comics, and its multiple renditions and silhouette are immediately recognizable even in the simplest of forms. Few images can claim such iconic flexibility: from the moment it was taken to its current global dissemination, a complex mesh of conflicting narratives has surrounded the image, from the bizarre to international lawsuits. *Rashomonesque* in its multiple guises, *Guerrillero Heroico* has remained fluid and buoyant, yet its meaning is clear even to those who know little about the man portrayed.

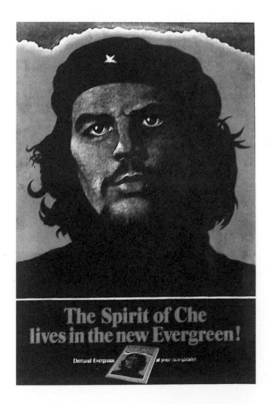

The Spirit of Che lives in the new Evergreen! Designed by Kenneth Dearoff after the painting by Davis used as a magazine cover for *Evergreen Review*, February 1968. (See page 120)

CHE LIVES! Brian Wallis

Improbable as it may seem, nearly forty years after his death, the Cuban revolutionary leader Ernesto 'Che' Guevara is now more famous than ever. His charismatic good looks and his revolutionary braggadocio have certainly played a part in making him the star attraction in recent on-the-road buddy movies and hip-hop iconography, but mostly Che's celebrity lives on because of a single iconic photograph, one that is so ubiquitous that it can be seen almost daily, anywhere in the world, reproduced on everything from baseball caps to computer mouse pads.[1] No matter that few people can tell you who took the picture of Che, or when. With his unfurled hair, his shaggy beard, his star-marked beret and his intense gaze towards the future, Che, in this momentary snapshot, has become the international logo for youthful rebellion and political resistance.

For many people, however, the easy commingling of revolution and commerce that allows Che's picture to sell merchandise as well as dissidence has been unsettling. Few were troubled more than Alberto Díaz Gutiérrez, the photographer known as Korda who took the original image in 1960. After repeatedly complaining about the misuse of his famous photograph, Korda filed a lawsuit in a British court in 2001 against Lowe Lintas, an advertising agency that had used the Che

Bag purchased in Los Angeles, 2005. (See page 115)

picture in a national campaign promoting Smirnoff Vodka. Korda's objection was apparently against not so much the unauthorized use of the image – after all, Cuba did not recognize copyrights – but rather the association of Che's image with frivolous products. He said at the time, 'As a supporter of the ideals for which Che Guevara died, I am not adverse to its reproduction by those who wish to propagate his memory and the cause of social justice throughout the world, but I am categorically against the exploitation of Che's image for the promotion of products such as alcohol, or for any purpose that denigrates the reputation of Che.'[2] The fact that Korda was victorious in the suit (he was awarded a substantial $50,000 judgment) signalled the continuing allegiance of international law to the proposition that the creator of an image should determine its use and its meaning.[3] The history of the Che image,

however, suggests the opposite: that its significance lies precisely in the unfettered circulation and multiple applications of the image to a wide variety of political causes and commercial ephemera.

Although Korda seems to have been given the last word on the proper use of his picture, the history of its appropriation, decontextualization and misrepresentation is far more compelling. The reception or consumption of this image by various audiences in various historical contexts, its transformation from mere document to universal symbol, involves not simply replication or regurgitation of the picture, but rather a wholesale rethinking and reinvention of it for each new venue. These successive regenerations involve, at each stage, an experimental negotiation between radical political content and new commercial contexts and a progressive distancing from the original photograph – and photographer. This last point – the supercession of the authorial figure of the photographer and the loss of fixed meaning his authority once provided – has proven particularly disturbing to many observers, and is in a sense what the copyright judgment sought to rectify. As the arbiter of meaning, the author has historically provided coherence and gravity. Quite another optic is required to accept an image that breaks free of its original source and is seen almost exclusively in reproduction, appropriated and transformed. Here, the question is less the moral or even political ramifications of the photograph's circulation – though those are crucial issues – than the process of transformation itself. Why and how was the image adapted and refashioned by different audiences for specific political purposes? How did Che become an icon? Here

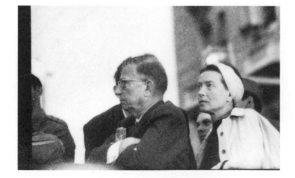

Contact sheet by Alberto Korda, enlarged, 5 March 1960. Colón Cemetery, Havana, Cuba. Courtesy of the Korda Estate. (See page 35)

lies the real political impact of the image, its representation not of one revolutionary moment but of proliferating instances of engagement in diverse political causes.

The tension between revolutionary utility and commercial triumph seem to have dogged the photograph's maker from the beginning. Korda, a former fashion photographer, was originally assigned by the Cuban government's daily newspaper *Revolución* to cover these events. The French intellectuals Jean-Paul Sartre and Simone de Beauvoir were in Cuba briefly to see the revolutionary state first-hand and to meet with its leaders. Korda had already recorded Sartre and Beauvoir's meeting with Che in his office at the Ministry of the Interior at 3 am one morning. Che appeared suddenly and momentarily at the dais, and Korda snapped two quick shots. On the contact sheet these two frames stand out from the other, more conventional assembly shots, since they show Che marvellously silhouetted against a white background, gazing out across the crowd. From a photojournalistic perspective, however, the pictures were of little value, and *Revolución* did not run them. Thereafter, the picture pretty much dropped from sight for seven years. Nevertheless, the image was familiar enough that on 18 October 1967, nine days after Che's shocking assassination in Bolivia, a monumental version of this portrait was displayed five storeys high on the Ministry of the Interior Building in Havana as Castro gave a funeral oration on the adjacent Plaza de la Revolución.

The widespread distribution of the photograph as a poster at about this same time has generally been characterized as an act of exploitation. In Korda's version of events, his image was hijacked in 1967 after he gave a copy of it to the leftist Italian

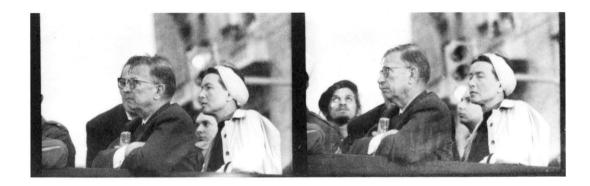

publisher Giangiacomo Feltrinelli. Just before Che's death, Feltrinelli mass-produced a poster using the portrait. Whatever the case, the poster – an enlargement of Korda's photographic portrait of Che bearing no text other than the Libreria Feltrinelli copyright notice (and no credit to the photographer) – was distributed internationally and signalled not only a new context for the image but also a new audience, for it was taken up by dissident youth throughout the world as a new emblem of revolution, particularly during the student protests of May 1968 in Paris.

Despite Korda's later objections, it was in fact Feltrinelli's savvy transformation of the Che portrait into a poster that secured its iconic status. For as David Kunzle, the foremost historian of the American protest poster, notes, this was the exact moment when the mania for posters coincided with the demands of a

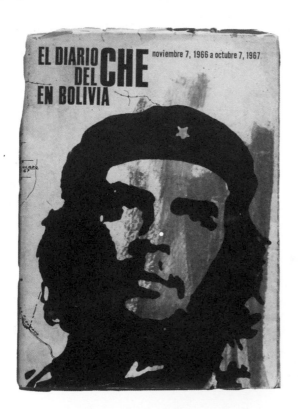

vast youth audience for posters of celebrities and political figures. 'In 1968 the poster craze was described as "half-way between a passing fashion and a form of mass hysteria," ' Kunzle wrote in 1970. 'Sales were then stated to have reached a million a month; and they may have more than doubled since. In 1966 there were very few places where one could buy posters, political or psychedelic… now, specialist stores, large and small have sprung up everywhere.'[4] Though triggered by the popularity of the rock poster, the poster boom of the late 1960s coincided with the growing international youth movement. For young protesters, posters became crucial bearers of often-satirical political messages, displayed either in public places or on dorm room walls. These posters remain largely unexamined and under-valued manifestations of the underground culture of the 1960s, in which the struggle for political justice was embodied in the rise of the political hero, the efflorescence of caricature as satire, the proliferation and politicization of poster-making as an information delivery system, the emergence of a vast international youth audience and the sophisticated coding of political resistance in the semiotics of music, literature, visual art and public protest.

Feltrinelli's application of Korda's image not only introduced the poster as the medium of choice but also divorced it from its photojournalistic origins. Subsequent posters pushed this abstraction of the image further, in ways that were influenced by the contemporary penchant for both satirical caricature and Pop celebration. One of the earliest and best-known variants of this poster was produced in several versions by the Irish activist artist Jim

Fitzpatrick in late 1967 (see page 21). Fitzpatrick recalls, 'Initially, I was working in a very Art Nouveau-ish style, like Beardsley, and the first image I did of Che was psychedelic, it looks like he is in seaweed. His hair was not hair; it was shapes that I felt gave it an extra dimension.' A second version was abstracted in a different way, with the features of the photograph very broadly outlined as black shapes that could be silk-screened against a flat, coloured background. This version, says Fitzpatrick, 'hit you in the face'.[5]

This second Fitzpatrick poster – the basis for the later Che brand – had such impact because it effectively utilized a Pop form of caricature, reducing the portrait to a high-contrast outline and enlivening the background with unmodulated flat colours. This technique was perfected by Andy Warhol as early as 1962, in his series of portraits of Marilyn Monroe, Elizabeth Taylor, Elvis Presley and, later, Jackie Kennedy.[6] By the period 1968 to 1972, this technique was familiar enough that artists like Fitzpatrick felt comfortable applying it to a host of different images and political purposes. In fact, Warhol's mastery of this approach and his own application of it to so many different personalities allowed his former assistant, Gerard Malanga, to produce a line of Che Guevara portraits that immediately sold out in a show in Rome as authentic Warhols (see page 79). In general, however, Warhol's motive was to produce serialized versions of tragicomic celebrities, while artists like Fitzpatrick had a more didactic political goal for which an eye-catching Pop image abstracted was particularly appropriate. The drastic abbreviation of the photographic portrait into a type of caricature allowed for easy reproduction, instant recognizability and a consistent message across various uses.

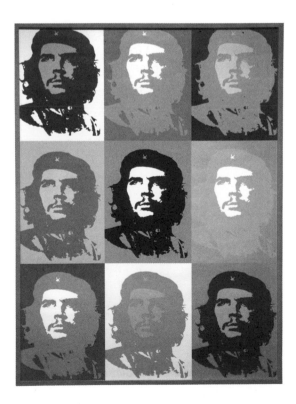

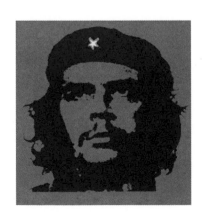

Left: *El Diario de Che en Bolivia by Che Guevara.* **7 November 1966 – 7 October 1967. Published in Cuba, first edition Instituto del Libro La Habana, 1968. Courtesy of Trisha Ziff. (See page 53)**
Right: **Jim Fitzpatrick,** *Che,* **1967.**
Far right: *'Warhol' Che* **(original, 1968) attributed to Gerard Malanga, Italy. Reproduction, 2000. Courtesy of Trisha Ziff. (See page 79)**

As a form of abstraction, caricature involves a motivation and a point of view, often a satiric perspective meant to challenge or mock a specific political situation. In the mid-1960s, caricature, often in the form of biting political cartoons, re-emerged with an explosive political effect not experienced since before the Second World War. The reviled American president Lyndon Johnson and his successor Richard Nixon proved extraordinarily susceptible to distortion and ridicule, particularly in posters protesting the war in Vietnam. But caricature was also used for valorization as, for instance, in the case of Milton Glaser's famous 1968 poster of Bob Dylan that featured the singer's famous profile topped by a rainbow-like swirl of stylized curls. A similar case, where a famous individual was represented by a few signature features, was that of Angela Davis, the charismatic feminist activist associated

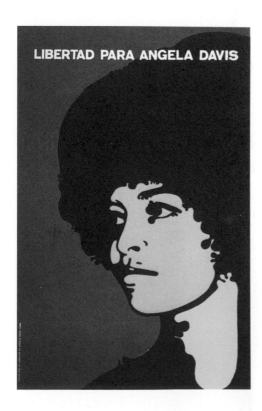

with the Black Panther party. She was depicted on numerous posters in the late 1960s reduced to a few easily recognizable and easily caricatured elements, most notably her Afro hair. Davis later ruefully recorded her impression of being caricatured: 'It is both humiliating and humbling to discover that a single generation after the events that constructed me as a public personality, I am remembered as a hairdo.'[7]

The widespread dissemination of the caricature of Che derived from the Korda photograph seems to have taken place almost immediately after his death. Posters utilizing Che's image were meant to celebrate not so much Che himself, as martyr, but rather to remind the Cuban people of the historical and political significance of the ongoing Cuban Revolution. For example, Cuban printmaker Frémez (José Gómez Fresquet) was preparing a dramatic poster featuring the Che image in October 1967, even before Che's death was confirmed. The poster shows Che's head printed very lightly in a black Ben-Day pattern on a brilliant red paper. The slogan in bold type below quotes Che: '*Hasta la victoria siempre*' (Ever Onwards Unto Victory), and seems to imagine even greater challenges and victories for Cubans. Frémez recalled that as he was printing the final poster, the news came of Che's death.[8] Other posters were produced rapidly for the shocked and grieving Cuban nation, many using Korda's image, but what is particularly fascinating is the way that very quickly the image spiraled away from Cuba and circulated throughout the world.

To clarify this point, I want to point briefly to three particular contexts in which the Korda photograph was deployed. Each

case is signalled by an exemplary poster, and each poster defines a strategic moment in which extraordinarily inventive uses of the Che image – now thoroughly divorced from Korda's photograph – served to crystallize urgent political issues of the late 1960s and early 1970s.

One poster (below) was designed by the Polish artist Roman Cieslewicz in 1967 and shows the abstracted image of Che with the words 'Che Si' emblazoned over his face. It was first used as the cover of a French arts magazine, *Opus International*, in October 1967, while Che was still alive, and then was widely circulated as a poster in 1968. This image and the seemingly self-evident Spanish phrase signal the internationalization of Che and the global impact of his image after his death. This poster, as well as the Feltrinelli version, was distributed throughout Europe in the tumultuous year 1968, when the student left, particularly in France, valorized Ho Chi Minh, Mao and Che as leaders of an international revolt against capitalism and Western imperialism. For them, the student and labour struggles in France were directly connected to political resistances elsewhere in the world: peasant revolts in Latin America, new national formations in Africa, religious conflict in Ireland, the cultural revolution in China, the civil rights movement in the United States and the war for self-determination in Vietnam. This internationalist framework for revolution, which was so central to Che's political philosophy, is also reflected in images that show Che in solidarity with other international figures, as in Alfredo Rostgaard's design for the cover of the September 1969 issue of *Tricontinental* magazine, which shows conjoined images of Che and Ho Chi Minh, both equally abstracted.

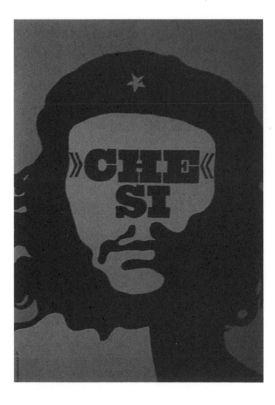

Left: *Liberty for Angela Davis*, 1970–71. Félix Beltrán. Committee for the Liberty of Angela Davis. Silkscreen print, 56.5 x 36 cm.
Right: *Che Si*, 1967. Roman Cieslewicz, France. 81 x 55 cm. Center for the Study of Political Graphics, Los Angeles. (See page 44)

Or, in a slightly different way, Che's international outreach is shown in posters that link him to all of Latin or South America. Here, the most famous example is Elena Serrano's often reproduced *Day of the Heroic Guerilla* poster from 1968 (see page 51), which shows telescoping images of Korda's photograph expanding to cover the entire red map of South America.

A second key poster is a rarely seen product of the Art Workers' Coalition, a New York-based group of artists whose protests were mainly directed at the war in Vietnam. This striking broadside from 1970 features the familiar Che outline on the left against a yellow background, and the famous quotation from Che: 'Let me say, at the risk of appearing ridiculous, that the true revolutionary is guided by great feelings of Love.' This sentiment found particular resonance among American audiences, seeming to conform nicely to

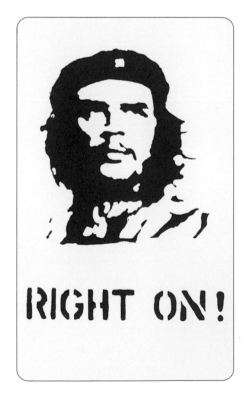

'*Right On!*', 1968.
Rupert Garcia. Silkscreen print; 66 x 51 cm.
Courtesy of the artist and the Rena Bransten Gallery, San Francisco.

the views of a certain segment of the protest movement in the United States that favoured non-violence, or at least compassion. Two slightly earlier, but closely related posters, with a stronger and less subtle message, also emerged from the protest movement in the United States and used the same stencil image of Che. The first, from 1968, is attributed to Rupert Garcia, and shows Che with the very un-Cuban slogan 'Right On!' (see left). The other, from 1969, was produced for a Berkeley student strike, and shows a cartoon bubble coming from Che's mouth with the command, 'Shut it down!' (see page 44). In each of these cases, Che (or at least the graphic caricature of Che) has been translated into a distinctly American idiom and has become a cipher merely for the prototypical and declamatory revolutionary leader.

A third key image was produced in early 1968 as a cover for *Evergreen Review*, a leftist cultural magazine published in the United States. Paul Davis made the original painting of Che that was used on the February 1968 cover, clearly basing it on the Korda photograph but giving it a more sensuous appearance. This is not the graphically reduced outline used elsewhere but a more humanistic version. It is set against a bright red background, according to the artist, to imitate the manner of Renaissance paintings of saints (see page 120).

As these and other reconfigurations of Korda's image demonstrate, signs can be emptied of meaning or repurposed to prove points the opposite from what was originally intended. Despite the spectacularization of the image of Che, what remains compelling are the many instances worldwide in

which that photograph persists as a rallying point for political struggles. To articulate resistance, to define local rebellions, to announce solidarity with others, activist artists will undoubtedly continue to remake, reclaim and recontextualize Korda's photograph, and in this way create what the English critic John Berger calls an 'alternative photography'. As Angela Davis has written, 'Perhaps by taking up John Berger's call for an "alternative photography" we might develop strategies for engaging photographic images... by actively seeking to transform their interpretive contexts in education, popular culture, the media, community organizing, and so on.... We need to find ways of incorporating them into "social and political memory, instead of using [them] as a substitute which encourages the atrophy of memory."'[9]

1: A complete line of Che consumables is available online at thechestore.com.
2: 'Photographer wins copyright on famous Che Guevara image', 16 September 2000.
3: More recently, in 2002, Korda's family sold the rights to the Che image to the Atlanta-based T-shirt manufacturer Fashion Victim. This contract caused some embarrassment when it was revealed that Fashion Victim T-shirts bearing the Che logo were made using Honduran sweatshop labour. See Harry Sheff, 'Che's image takes a twist', Utne Reader (2 September 2004)

4: David Kunzle, Posters of Protest: The Posters of Political Satire in the U.S., 1966–70 (Santa Barbara: University of California at Santa Barbara, 1971), p. 28. On posters of this period, see also Maurice Rickards, Posters of Protest and Revolution (New York: Walker and Company, 1970); Deborah Wye, Committed to Print (New York: Museum of Modern Art, 1988); and Carlo McCormick, et al., Decade of Protest: Political Posters from the United States, Viet Nam, Cuba, 1965–1975 (Santa Monica, Ca: Smart Art Press, 1996).
5: Jim Fitzpatrick, quoted in Aleksandra Mir, 'Not everything is

always black or white', 3 January 2005, www.aleksandramir.info. Fitzpatrick showed a silver-foil version of his poster in an exhibition titled Viva Che held at the Arts Laboratory in London in the spring of 1968.
6: On Warhol, see Benjamin H.D. Buchloh, 'Andy Warhol's one-dimensional art: 1956–1966', in Kynaston McShine, ed., Andy Warhol: A Retrospective (New York: Museum of Modern Art, 1989), pp. 53ff.
7: Angela Davis, 'Afro images: politics, fashion, and nostalgia', in Deborah Willis, ed., Picturing Us: African American

Identity in Photography (New York: New Press, 1994), pp. 171.
8: Kunzle, Che Guevara, p. 59. A similar poster, bearing the same slogan, and multiple images of the Che photograph, was made slightly later by the Cuban designer Niko (Antonio Pérez González). See ibid., p. 22.
9: Davis, 'Afro images', p. 178. Davis is quoting from John Berger, About Looking (New York: Pantheon, 1980), p. 57.

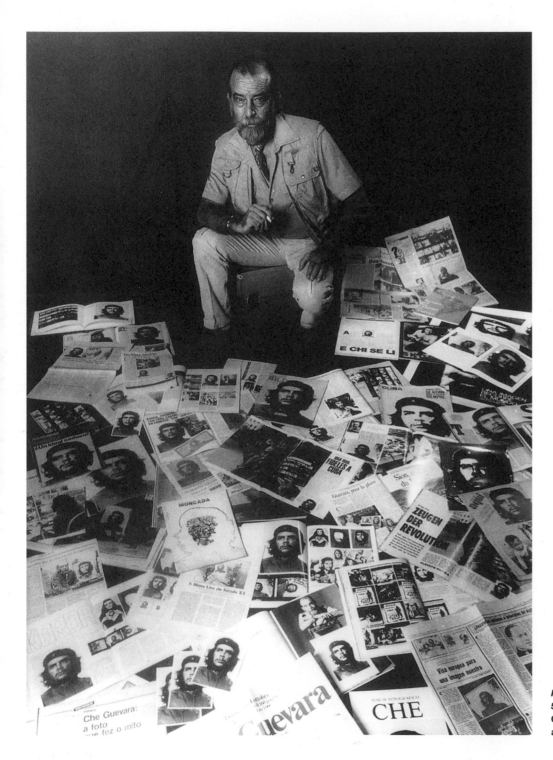

Korda. 30 Aniversario de una foto,
5.03.1990. **José Figueroa, Havana,**
Cuba. Courtesy of the photographer
and Couturier Gallery, Los Angeles.

ORIGINS

IT IS MY BEST-KNOWN PHOTO-
GRAPH. IT WASN'T TAKEN, AS
MANY PEOPLE THINK, IN A
STUDIO, BUT ON A STAGE ON
23RD STREET AT THE FUNERAL
FOR THE VICTIMS OF THE SHIP LA
COUBRE THAT WAS SABOTAGED.
IT'S AN IMAGE THAT SHOWS
CHE'S CHARACTER – THE FIRMNESS,
STOICISM, RESOLUTENESS.
ALBERTO KORDA

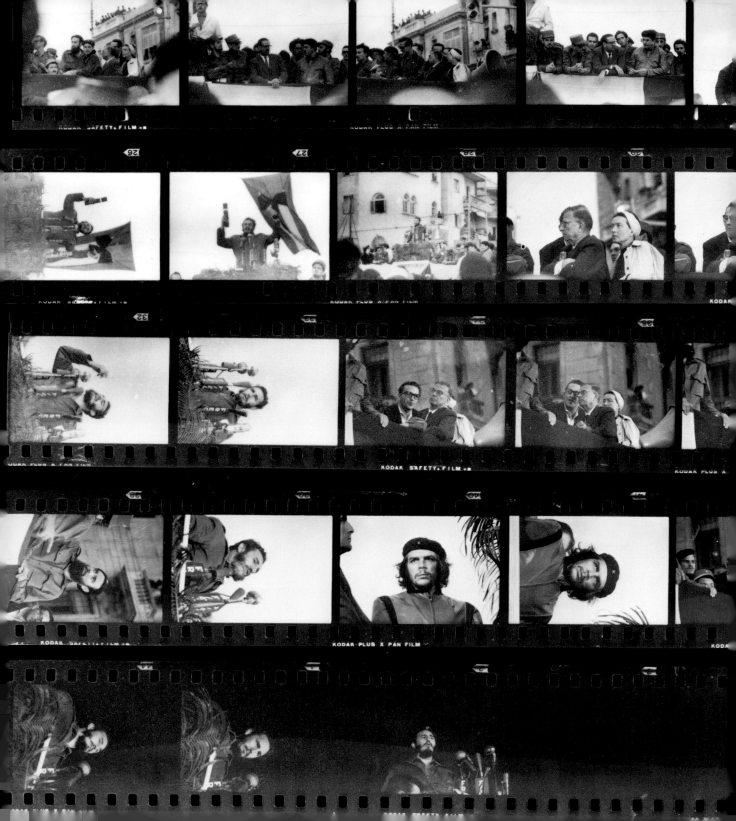

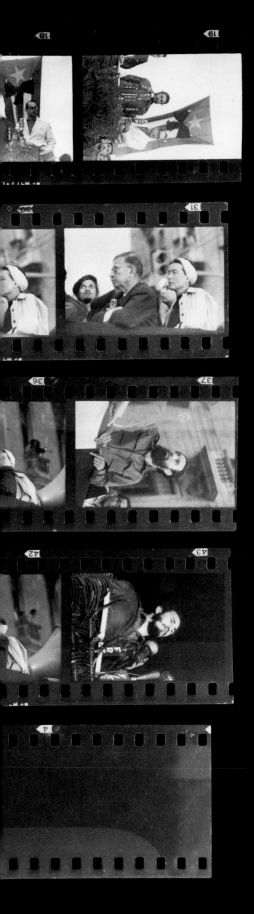

'A portrait of Che accomplished more for his cause than the man himself accomplished in his lifetime.'
Vicky Goldberg, *The Power of Photography*, 1991.

'My father had not always been a photographer. When I was born, he worked as a travelling salesman, selling medicines and then selling IBM and Remington typewriters. One time he met this photographer and was trying to sell him a typewriter. My father in order to ingratiate himself with the man told him he was an aficionado of photography. So, this man told him that he should come back and bring his photos. When he brought him the photographs, the man told him, "My advice to you is to stop selling typewriters," and so my father dedicated himself to photography. It must have been around 1953. So from such beginnings, he ended up taking the most reproduced image of our time.'
Diana Díaz, daughter of Alberto Korda. Extract from an interview with Darrell Couturier, Havana, Cuba, 2005.

Left: **Contact sheet by Alberto Korda, 5 March 1960. Colón Cemetery, Havana, Cuba. Courtesy of the Korda Estate.**

Next spread: **Korda in his home. Photograph by Marcos López. Havana, Cuba, 1996.**

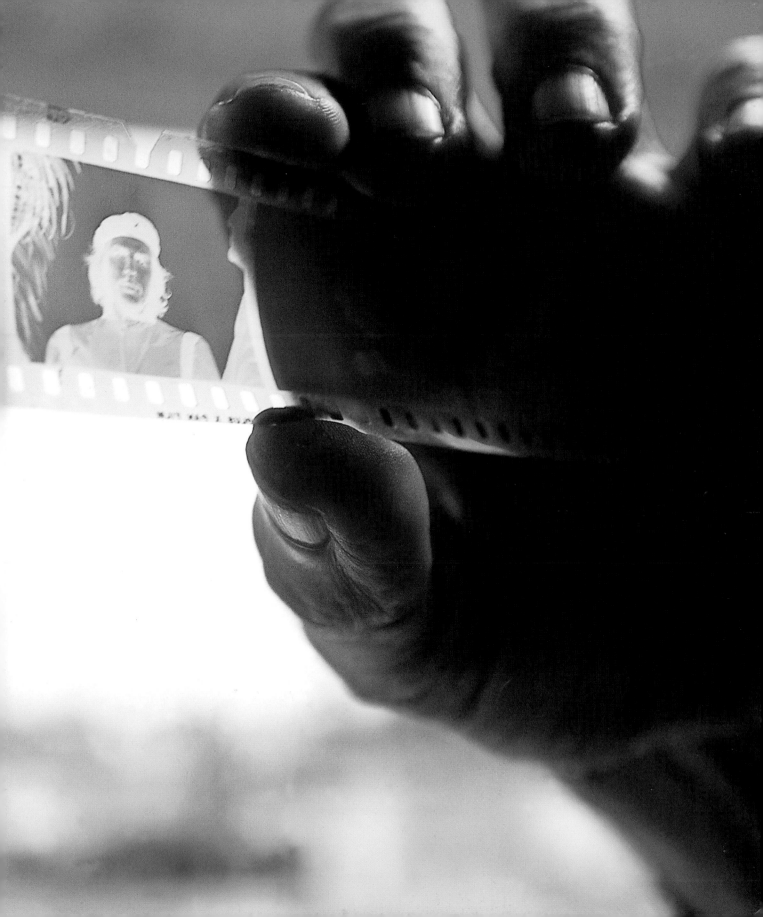

'I am going to be frank with you. As custodian of my father's work, this image gives me more problems and headaches than any of his other images! We are constantly demanding that the use of this image be respected. It's not that it shouldn't be used; the idea isn't that the image should not be reproduced…. My father wasn't opposed to the image being used. He opposed its misuse. He never wanted it to be used to sell alcohol or cigarettes or perfume. Just recently I received material promoting a pornographic movie with an image of Korda's Che with a naked man gesturing provocatively in the foreground.

Despite the fact that there is a new generation, many of whom do not know anything about Che's life, I think the icon will remain significant, because it has become a symbol beyond the man himself, but I also think there will always be those who are restless, the curious, who will want to know who Che Guevara was. They may be the minority, but over time I believe that besides being an icon Che will be remembered through this image. I know that often, especially young people buy a T-shirt with the image of Che on the front without knowing who Che was. They buy it because they know it says "rebellion", and because it is the style, not because they understand or identify with Che's vision. But there are those who will buy the T-shirt and then ask the question, "Who was Che?"'
Diana Díaz, daughter of Alberto Korda. Extracts from an interview with Darrell Couturier, Havana, Cuba, 2005.

Guerrillero Heroico by Alberto Korda, March 1960, Havana, Cuba. Courtesy of the Korda Estate.

KODAK · PLUS

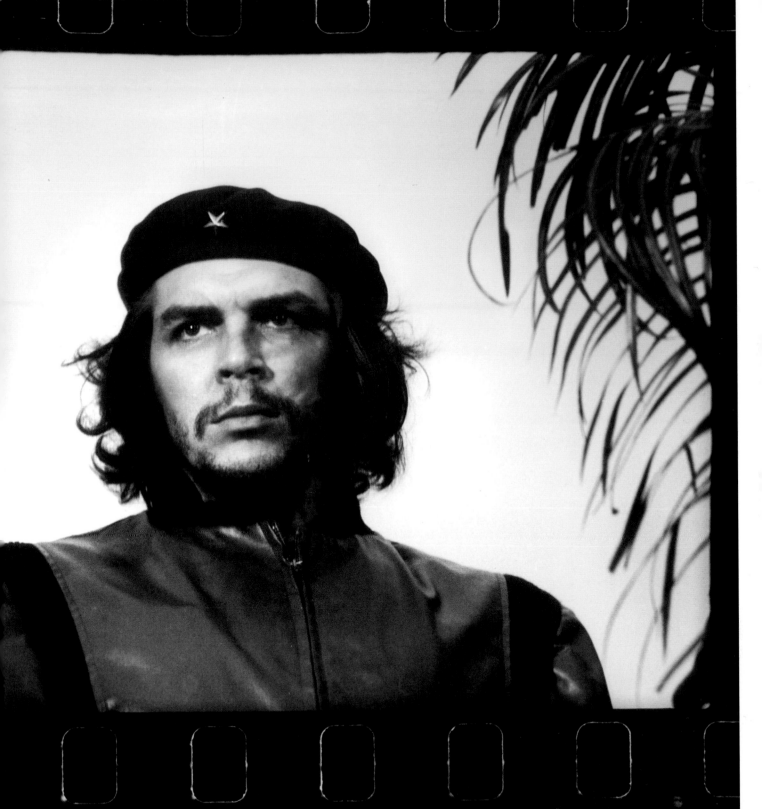

PAN FILM

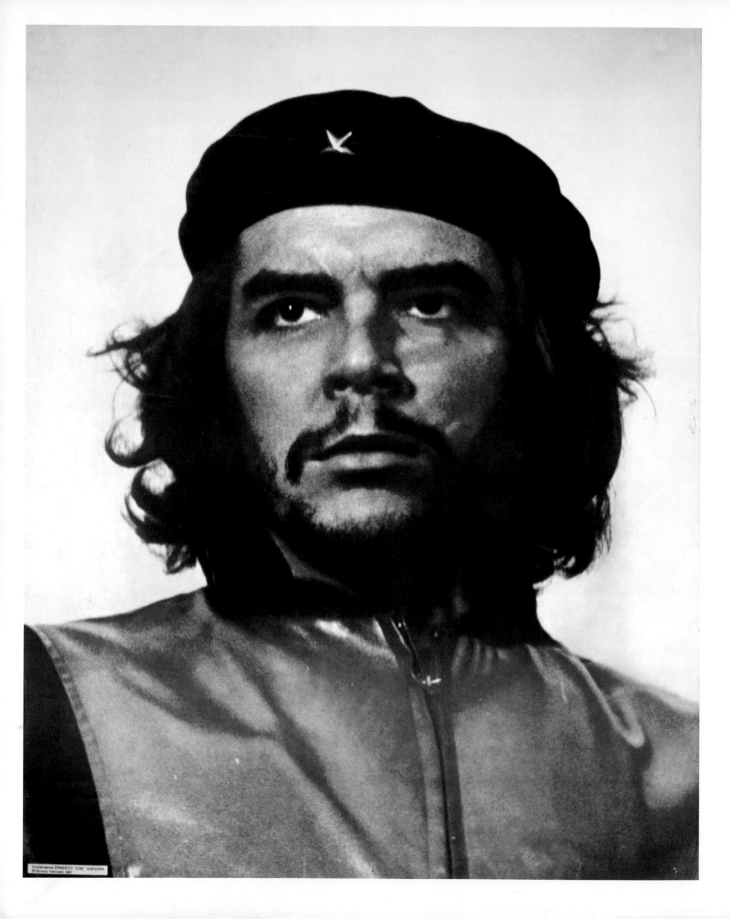

'The "Korda Matrix" was compared in large lithographs by an Italian visiting Havana in 1989 to the Mona Lisa, reproduced in miniature together with Korda's Che. The Italian magazine Skimé makes the comparison, stating that the photograph is "absolutely the most famous of history" and "captures beauty and youth, courage and generosity, aesthetic and moral virtues" of a person who "possessed all the characteristics necessary to be converted into a symbol of an epoch like ours, lacking in historic legends and mythic incarnations". In terms of fame and convertability to other uses, Leonardo's portrait has a head start of more than 460 years, but as a politically motivating icon, the Korda Che may well rank with some atrocity photographs from Vietnam as among the most enduring of the twentieth century,'
David Kunzle,
Che Guevara: Icon, Myth and Message, 1997.

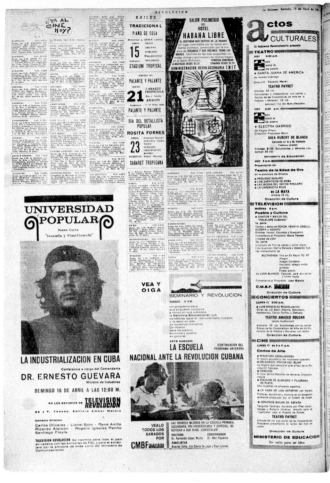

Left: ***Comandante Ernesto 'Che' Guevara**, Feltrinelli, 1967.
Courtesy of the Instituut voor Sociale Geschiedenis, Amsterdam.
Top right: **Korda's Che was first published on 16 April 1961 in Cuba in the daily newspaper *Revolución*. The conference the image advertised was disrupted by the events of that day: the invasion of the Bay of Pigs. The image was republished a second time (see page 15) advertising the newly convened conference on 28 April 1961.
Courtesy of the Newspaper Archives of Cuba, Consejo de Estado Oficina de Asuntos Históricos.**
Bottom right: **'Les Guérilleros', article by journalist Jean Lartéguy. *Paris Match*, August 1967.**

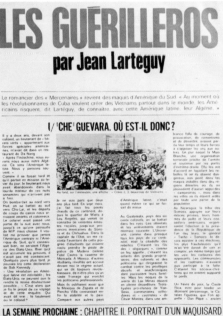

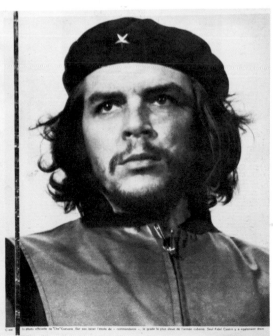

PHOTO GRAPHIC

CONVERTED INTO A STARK BLACK
CUT-OUT, KORDA'S PHOTOGRAPH
BECAME EASY, CHEAP AND
SUPER-FAST TO COPY USING THE
FAVOURED MATERIAL AND
METHOD OF THE 1960S: LITH FILM
AND SCREENPRINTING. HAD CHE
GUEVARA BEEN MURDERED IN
THE AIRBRUSHED '70S HIS FACE
MIGHT NOT HAVE MADE SUCH A
LASTING, ICONIC IMAGE.
NICK BELL

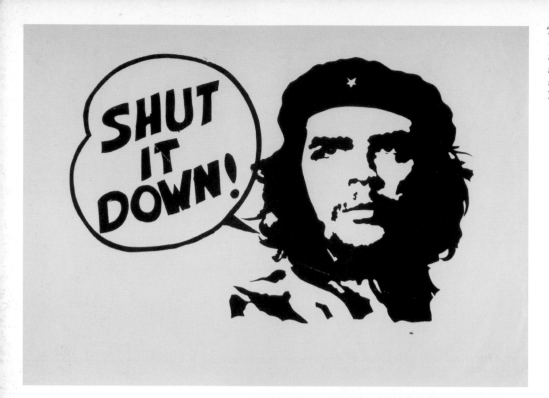

'It is at this moment, when Che was known to be "somewhere in Bolivia" taking incalculable risks, that he was, as far as I can tell, first apotheosized in art.' David Kunzle, 1997.

Previous page: *Hasta La Victoria Siempre*, October 1967. Frémez (José Gómez Fresquet), Havana, Cuba. 59.5 x 44.5 cm. Center for the Study of Political Graphics, Los Angeles.

Top: *Shut It Down!*, 1969. Artist unknown. Student strike poster, University of California, Santa Barbara. Silkscreen print, 51 x 76 cm. Center for the Study of Political Graphics, Los Angeles.
Left: *Che Si*, 1967. Roman Cieslewicz, France. 81 x 55 cm. Center for the Study of Political Graphics, Los Angeles.
Right: *Viva Che*, 1968. Jim Fitzpatrick, Ireland. Screenprint on foil. 75.5 x 50 cm.

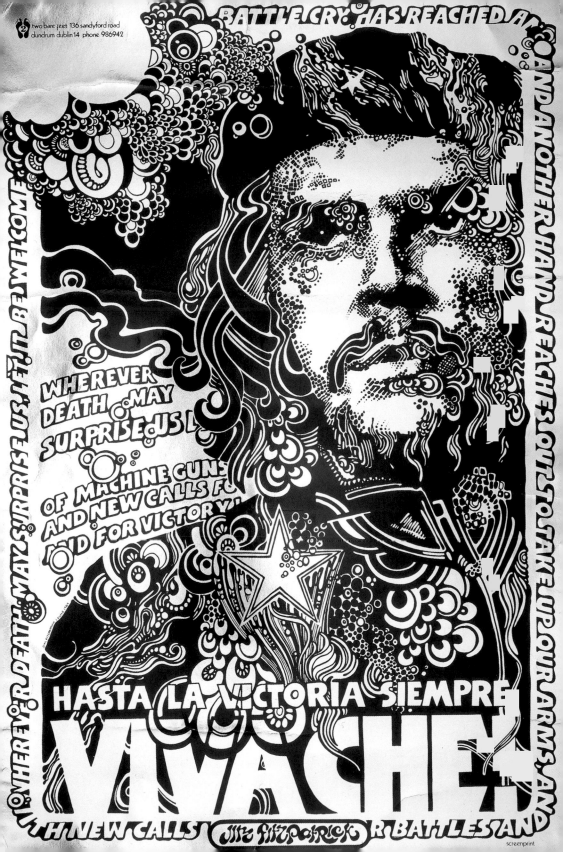

Left: *Wherever death may surprise us, let it be welcome, as long as this, our war cry, reaches a receptive ear*, 1973. Lamieras, Cuba. Offset litho, 98.5 x 52 cm. Center for the Study of Political Graphics, Los Angeles. Taken from Che's message to the Tricontinental, 1967. The face of Che is composed of twenty-five homages from writers around the world.

Right: *The Party is Today the Soul of the Cuban Revolution*, 1980. Artist unknown. Offset litho, 76 x 50.8 cm. Center for the Study of Political Graphics, Los Angeles.

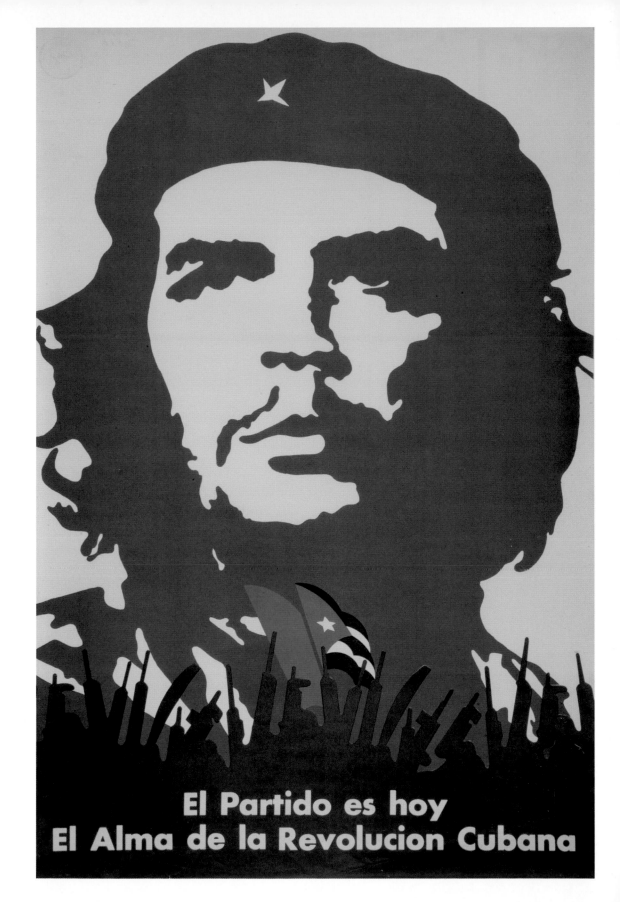

**El Partido es hoy
El Alma de la Revolucion Cubana**

Left: ***Day of the Heroic Guerrilla Fighter***, 1969. Jesús Forjáns, Cuba. OSPAAAL (Organization of Solidarity of the People of Asia, Africa and Latin America). Offset print, 50 x 35 cm. Center for the Study of Political Graphics, Los Angeles.

Above: ***Untitled.*** Félix Beltrán. Silkscreen print, 47 x 38 cm. Originally from Cuba, Beltrán lives today in Mexico City. A prolific artist and designer, he has made over fifty posters using the Korda Che image. Center for the Study of Political Graphics, Los Angeles.

Top right: ***Che,*** *c.* 1990. Daysi García, Cuba. Ink drawing, 48 x 39.5 cm. Center for the Study of Political Graphics, Los Angeles.

Bottom right: ***Untitled,*** *c.* 1970. Félix Beltrán. ICAP (Cuban Institute for Friendship with Other Peoples). Silkscreen print, 56 x 43 cm. Center for the Study of Political Graphics, Los Angeles.

ICAP - CUBA

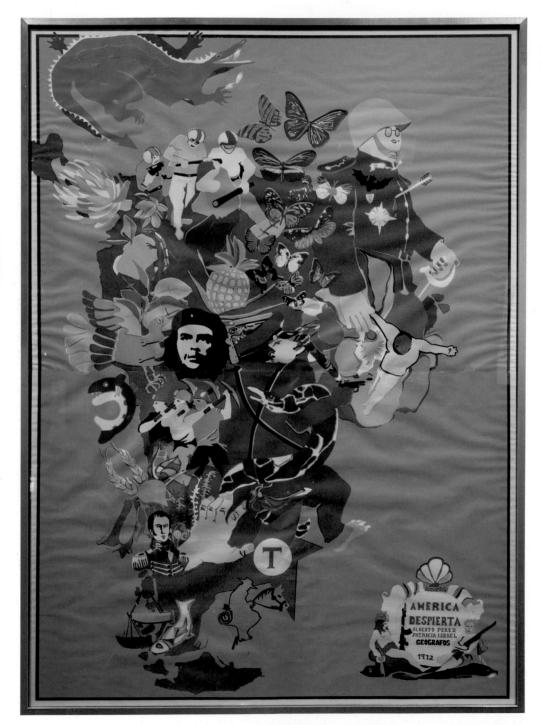

Left: *America Awaken(s)*, 1972.
Patricia Israel and Alberto Pérez,
Chile. Silkscreen print composite
of two sheets, 145 x 109 cm.
Center for the Study of Political
Graphics, Los Angeles. Chilean
dictator Augusto Pinochet's troops
burned a copy of this poster along
with subversive literature during
the coup of 11 September 1973.
The image of Che is placed over
Bolivia. The photograph (above) of
the burning of the books is an
unknown wire image (1973).
Right: *Day of the Heroic Guerrilla,
8 October 1968.* Elena Serrano,
Cuba. OSPAAAL. Offset print,
50 x 33 cm. Center for the Study of
Political Graphics, Los Angeles.

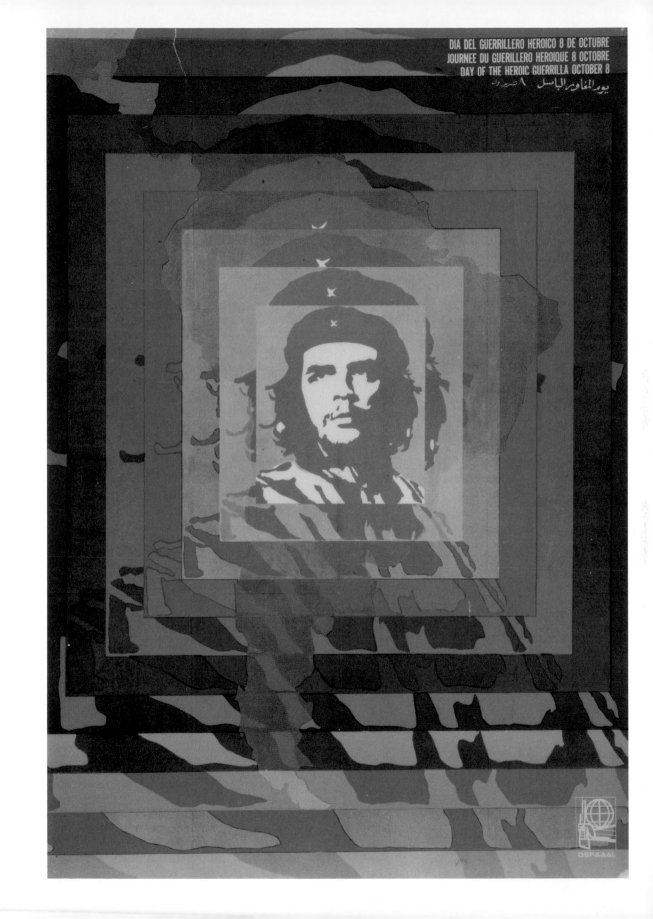

DIA DEL GUERRILLERO HEROICO 8 DE OCTUBRE
JOURNEE DU GUERILLERO HEROIQUE 8 OCTOBRE
DAY OF THE HEROIC GUERRILLA OCTOBER 8

يوم المغاور الباسل ٨ تشرين

OSPAAAL

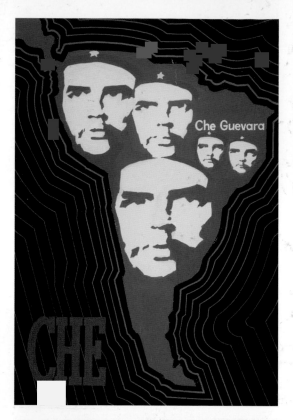

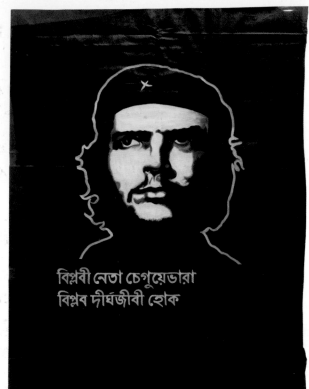

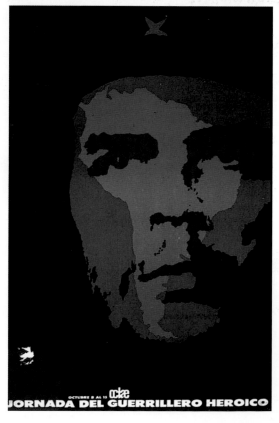

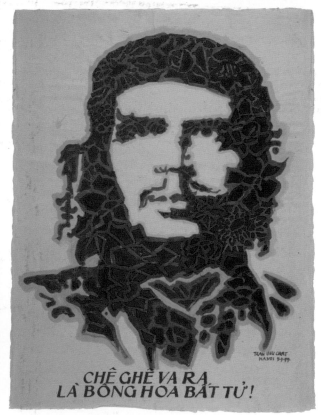

CHÊ GHÊ VA RA,
LÀ BÔNG HOA BÂT TỬ!

Opposite page.
Top left: **Che Portrait Inside South America**, 1996. Ngô Ba' Tháo, Vietnam. Acrylic, 75 x 54 cm. Center for the Study of Political Graphics, Los Angeles.
Top right: **Bangla Che, 'Revolutionary Leader Che Guevara. Long Live the Revolution'**, Bangladesh, 2004. Hand-painted rickshaw painting, 94 x 71 cm. Courtesy of Shahidul Alam, DRIK Picture Library Ltd.
Bottom left: **Day of the Heroic Guerrilla,** 8–15 October, year unknown. Artist unknown, Cuba. OCLAE (Continental Latin American Student Organization). Offset print. Center for the Study of Political Graphics, Los Angeles.
Bottom right: **Chê ghê va ra**, 1997. Tran Huu Chat, Vietnam. Ink drawing, 71 x 62 cm. Center for the Study of Political Graphics, Los Angeles.
This page.
Top left: **Pombo tells us about Che Guevara**. Iran, date unknown. Translation from the Farsi on back cover: 'Harry Villegas, known as Pombo, fought with Che Guevara in Cuba, Congo, Bolivia. Villegas talks about his efforts and what was achieved during this decade as a memoir of a soldier, looking at Che, his thinking and his role as a political thinker, and describes his fight against imperialism.' (translation by Alireza Soodmand).
Courtesy of Trisha Ziff.
Top right: **Cover of *Tricontinental*,** issue 92, 1974. Artist unknown. 21.5 x 15.5 cm.
Bottom left: **El Diario de Che en Bolivia by Che Guevara**. 7 November 1966 – 7 October 1967. Published in Cuba, first edition Instituto del Libro La Habana, 1968. Courtesy of Trisha Ziff.
Bottom right: **Guerrilla Warfare by Che Guevara**, no date. Editorial de Ciencias Sociales, Cuba. Courtesy of Trisha Ziff.

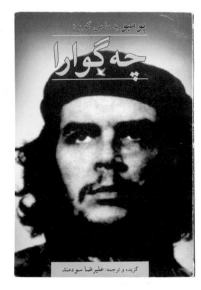

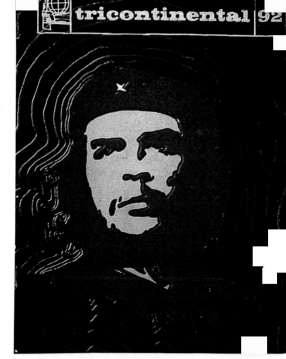

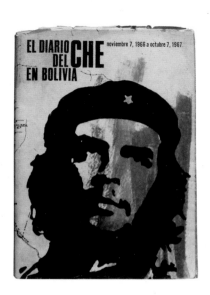

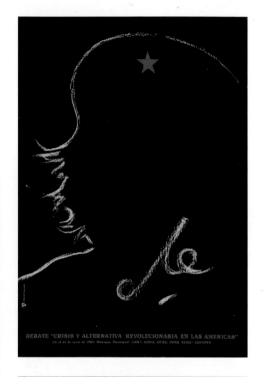

DEBATE "CRISIS Y ALTERNATIVA REVOLUCIONARIA EN LAS AMERICAS"

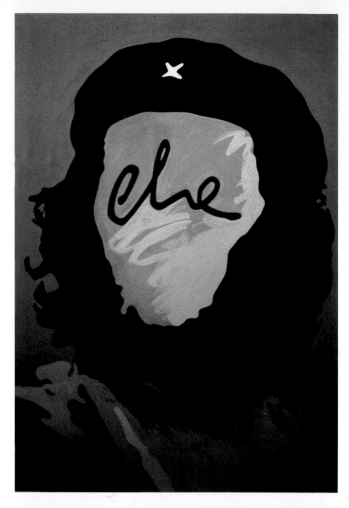

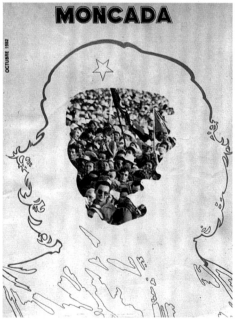

MONCADA

OCTUBRE 1992

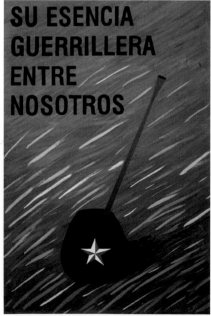

SU ESENCIA GUERRILLERA ENTRE NOSOTROS

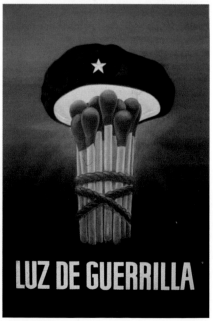

LUZ DE GUERRILLA

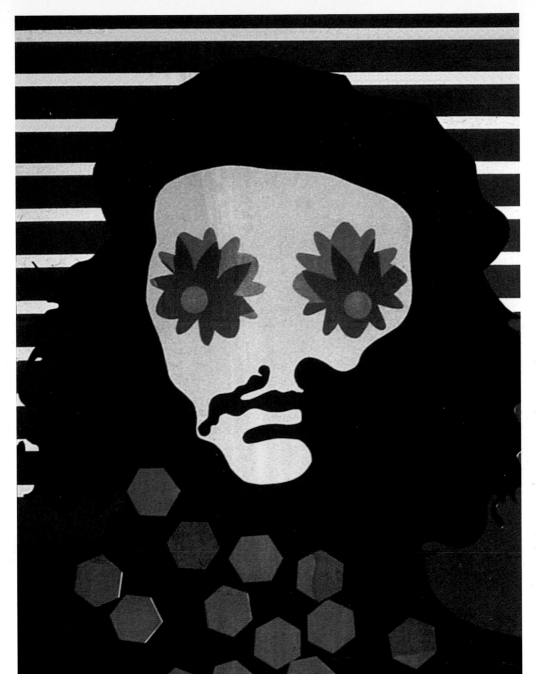

Opposite page:

Top left: **Poster for *Debate, Crisis and Revolutionary Alternative in the Americas*, 15 June 1987. Vanguardia Press, Managua, Nicaragua. Offset litho, 61 x 42 cm. Center for the Study of Political Graphics, Los Angeles.**

Top right: **Design exhibited in Imagen Constante, Havana, 1997. Slide collection of David Kunzle.**

Below left: ***Moncada*, October 1982. This presumably makes reference to the barracks and the battle of Moncada: the first armed action against Batista of the revolution. The poster was possibly produced for an anniversary of this battle. Slide collection of David Kunzle.**

Below centre: ***The essence of his fight is amongst us.***
The *mate* makes reference to Che Guevara being from Argentina, as the symbol on the black beret is transformed into a cup of *yerba mate*. *Mate* is drunk from a cup, traditionally a hollowed-out gourd, through a *bombilla*, a straw. Usually it is shared and passed around amongst friends in an intimate ritual in which the cup is refilled and the tea sucked through the straw. Slide collection of David Kunzle.

Below right: ***Guerrilla light.***
Design exhibited in Imagen Constante, Havana, 1997. Slide collection of David Kunzle.

This page:
Design exhibited in Imagen Constante, Havana, 1997. Slide collection of David Kunzle.

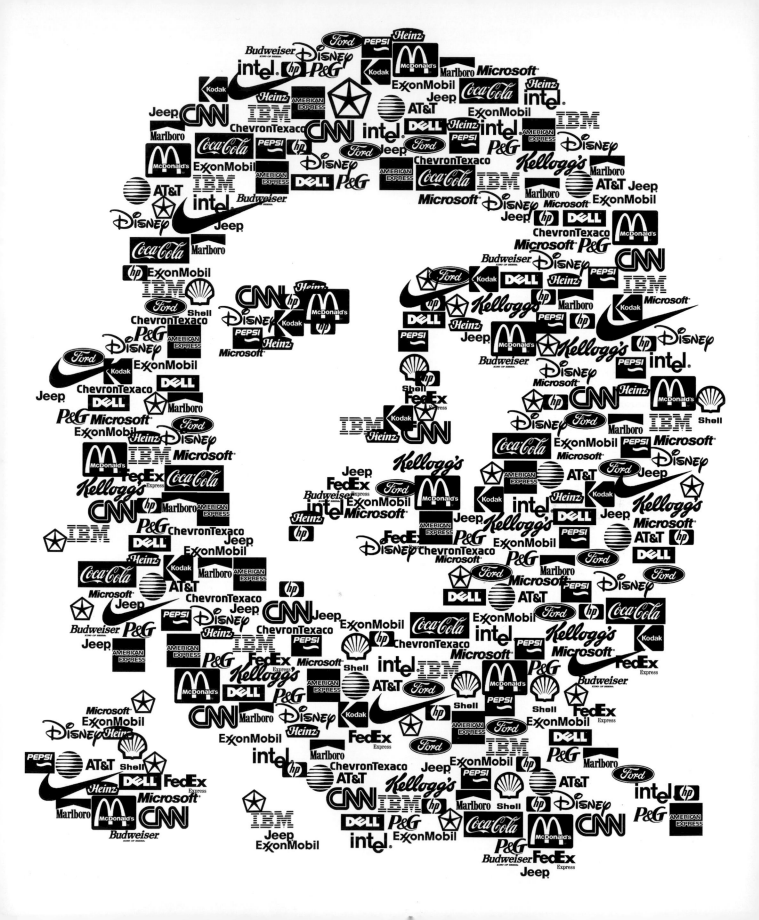

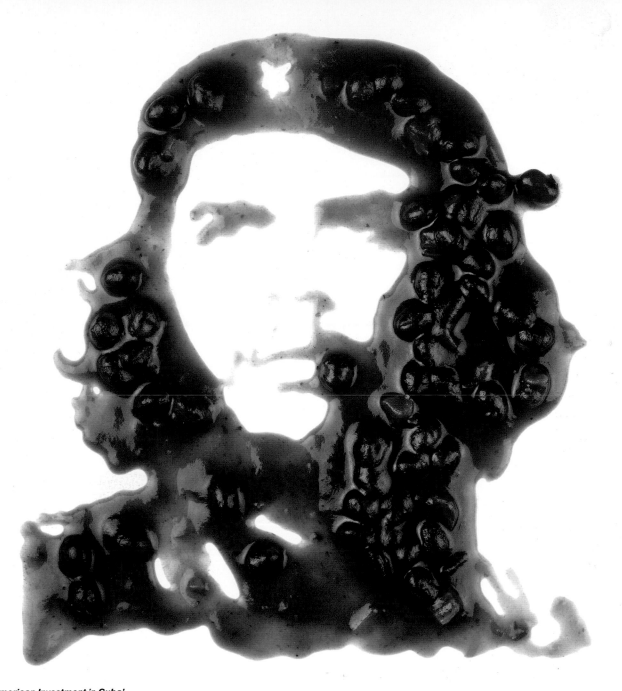

Left: *'American Investment in Cuba'*, 2002. Patrick Thomas. Silkscreen print, 112 x 76 cm. Originally published as Financial Supplement cover image for *La Vanguardia* newspaper, Barcelona. Courtesy of the artist.

Above: *Che Frijol*, 2000. Vik Muñiz. Cibachrome print, 81 x 101.5 cm. Courtesy of the photographer and Galerie Xippas, Paris.

WALL

CHE CAN BE FOUND JUST WHERE
HE BELONGS: IN THE NICHES
RESERVED FOR CULTURAL ICONS,
FOR SYMBOLS OF SOCIAL
UPRISINGS THAT FILTER DOWN
DEEP INTO THE SOIL OF SOCIETY,
THAT SEDIMENT IN ITS MOST
INTIMATE NOOKS AND CRANNIES.
JORGE CASTAÑEDA

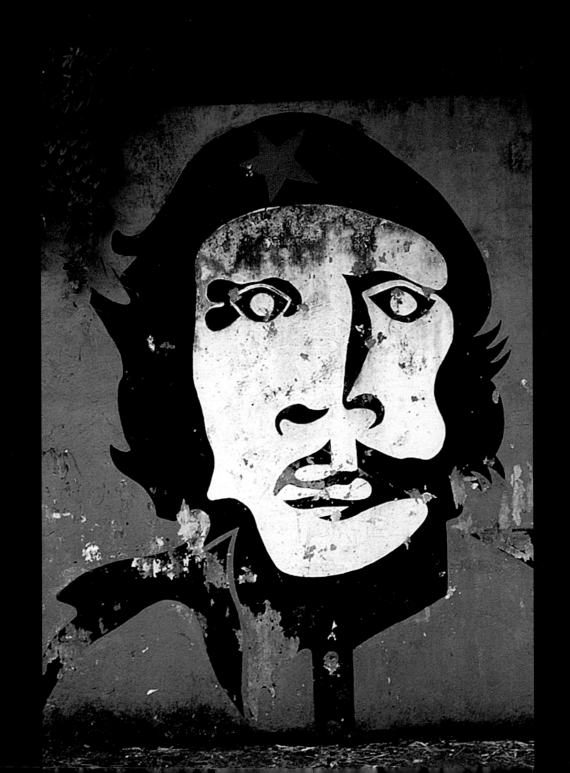

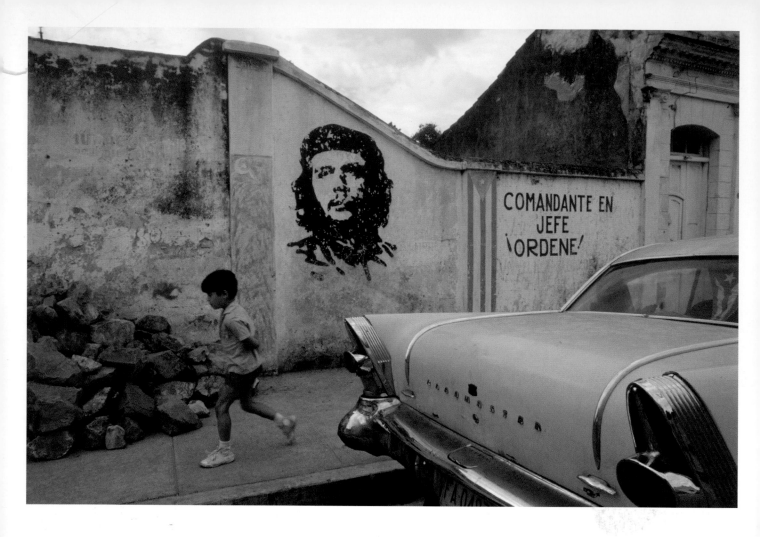

Previous page: *Untitled*, 1981–3.
**Photograph by David Kunzle,
Grenada. This mural is over
3 metres high. It was destroyed
during the American invasion
of Grenada in 1983.**

Above: *Commander-in-Chief,
at your order!*, 1984. Trinidad, Cuba.
René Burri, Magnum Photos.
Right: **Che Guevara graffiti on a
wall, 2003. Bethlehem, Palestine.
Larry Towell, Magnum Photos.**

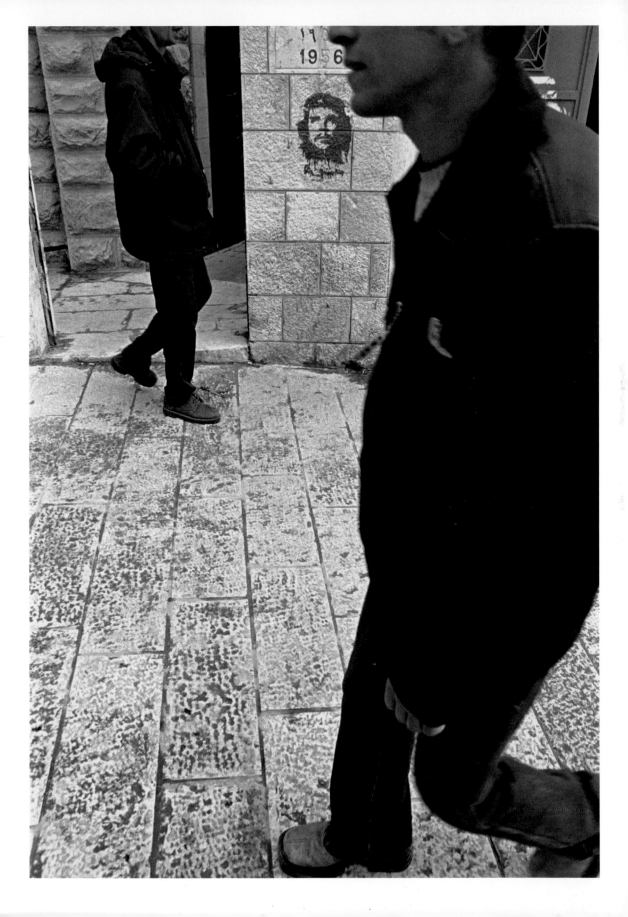

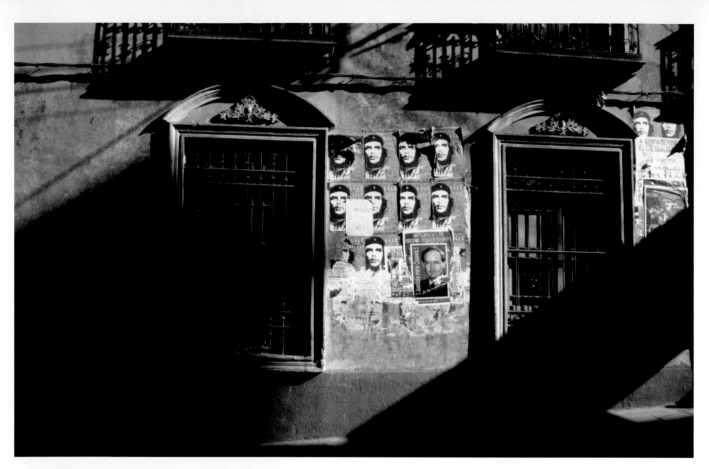

Above: *Untitled*, 2002.
Carol Hayman, La Paz, Bolivia.
Courtesy of the photographer.
Left: *Workers clean portrait
of Guevara*, 1997. Artist unknown,
Havana, Cuba. Since the death
of Che Guevara the wall of
the Ministry of the Interior in the
Plaza de la Revolución in Havana
has been dedicated to a portrait
of Che.
Right: *Untitled*, 2003. Raúl Ortega,
Culiacán, Sinaloa, Mexico.
Courtesy of the photographer.

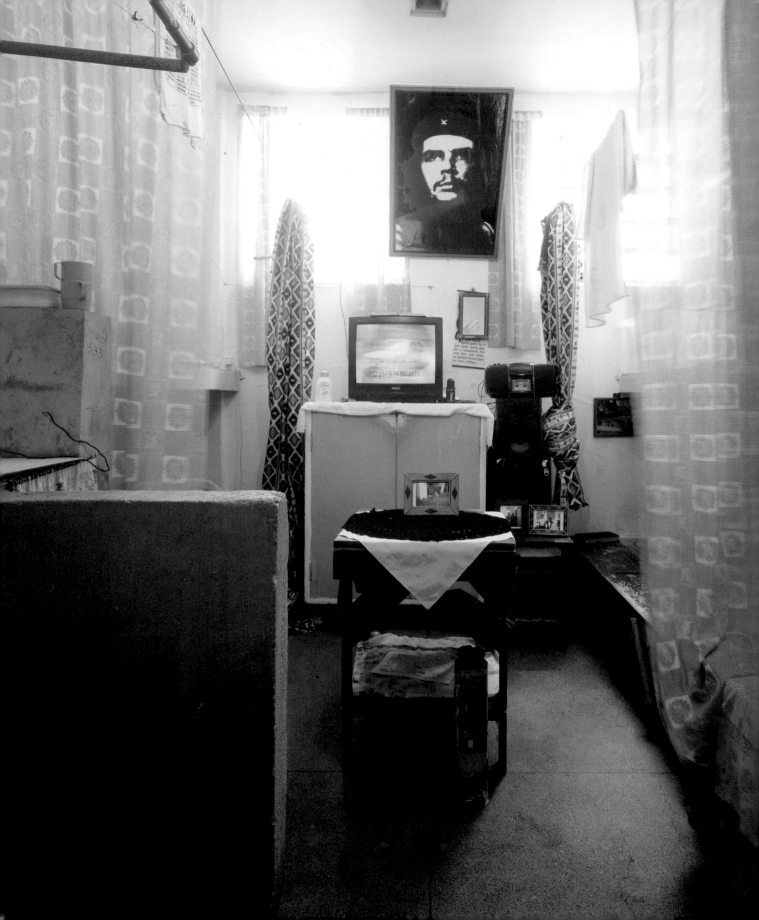

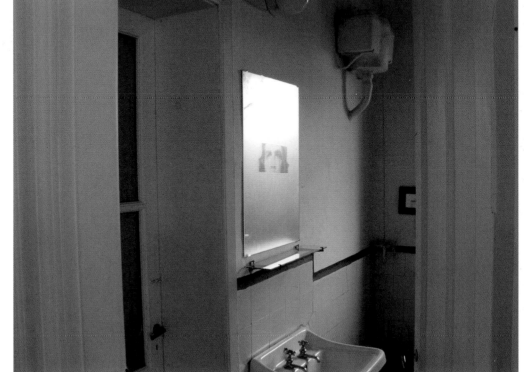

Left: **Untitled**, 2002. Carandiru Penitentiary, Sao Paulo, Brazil. Pedro Lobo. Courtesy of the photographer. This prison cell is within the Carandiru Penitentiary and was the site of an infamous massacre on 2 October 1992 when 111 prisoners were shot dead by military police, who remain untried. The prison was demolished in March 2003.

Top right **A Friend's Apartment**, 2003. Brian Doan, Denver, Colorado. Courtesy of the photographer.

Bottom right **Bathroom Mirror at the Museo del Che**, 2004. John R. Harris, Alta García, Argentina. Courtesy of the photographer.

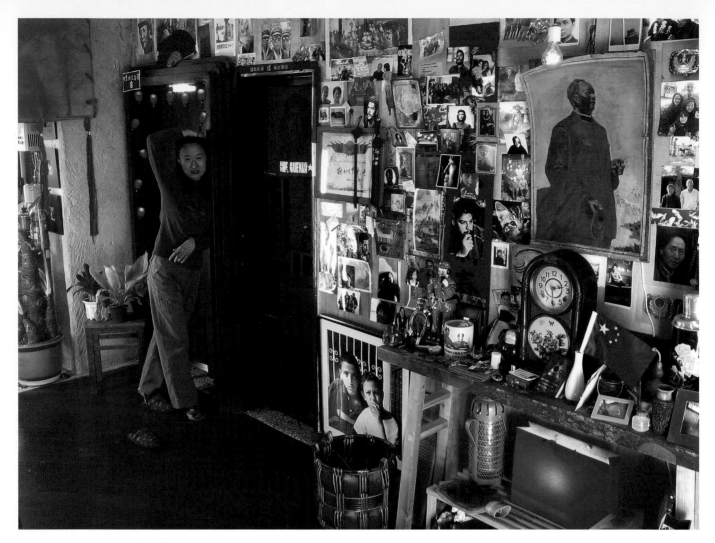

'Revolution is not a dinner party,
nor an essay, nor a painting, nor
a piece of embroidery; it cannot
be advanced softly, gradually, care-
fully, considerately, respectfully,
politely, plainly and modestly. A
revolution is an insurrection, an
act of violence by which one class
overthrows another.'
Mao Zedong.

Above: *Untitled*, 2004. Zhao Hai Yun,
Beijing, China. Courtesy of the
photographer.
Right: *In the House of the 'Witch'
and Healer Caridad Miranda*, 1994.
Viñales, Cuba.
Thomas Hoepker, Magnum Photos.

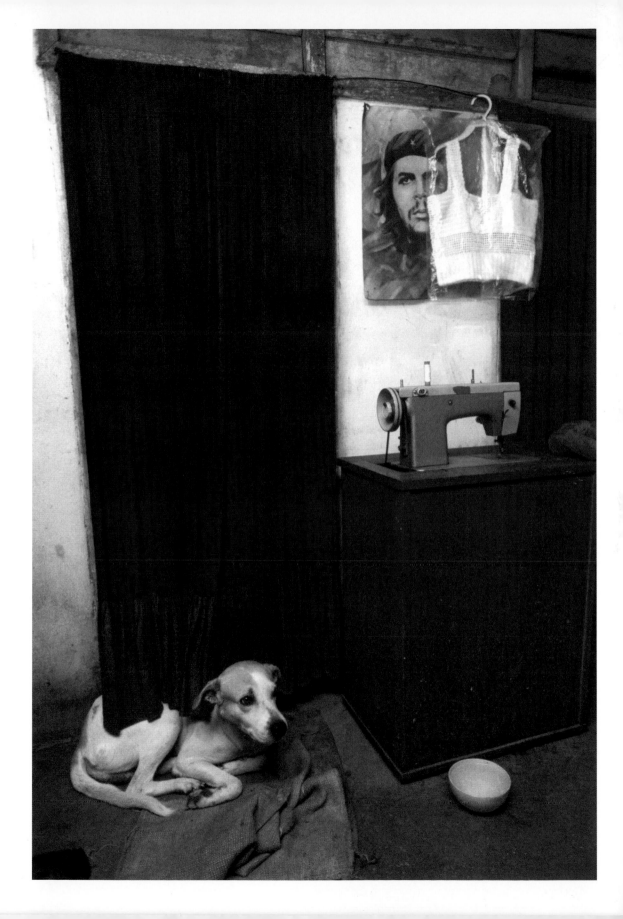

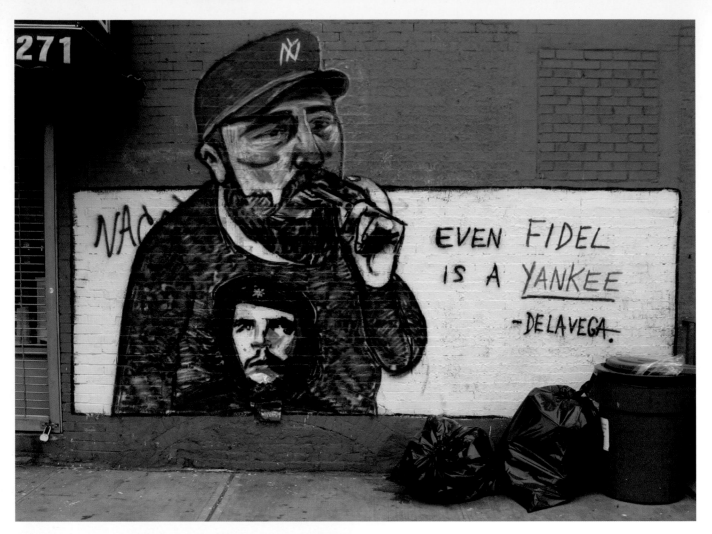

Above: *Even Fidel is a Yankee,
New York City*, 2004. Photograph by
John R. Harris. Courtesy of the
photographer.
Left: *Oventic, Chiapas*, 2004.
Raúl Ortega. Courtesy of the
photographer.

REVOLUTION

THE REVOLUTION IS NOT AN
APPLE THAT FALLS WHEN IT IS RIPE.
YOU HAVE TO MAKE IT FALL
CHE GUEVARA

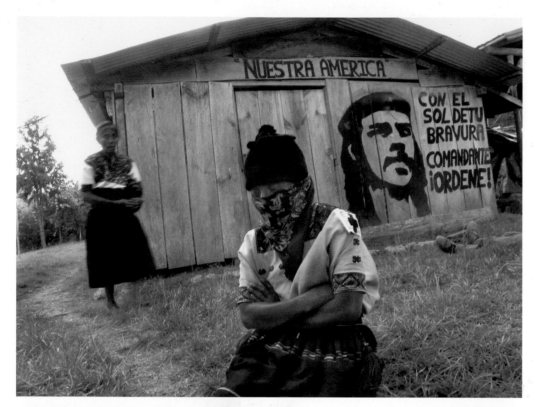

'The international revolution was never followed by others, and the homeland of the new man sails alone in the Caribbean. One of Che's sons is a dissident, and one of his nephews a rock star who sings in English patiently waiting his time to move to the United States of America, if not gone already. Nonetheless, with the recent and euphoric globalization, the image of Che prevails as an activist icon amongst many in the Western world. Within the indigenous neo-Zapatistas in Chiapas, the image of Che blends in with that of Christ, Virgin Mary, truck drivers, vendettas, taggers, commercialists, popular musicians, and gangsters of Mexico and other countries. These people wear him as an accent on their clothing and stickers on their vehicles, as if the image still maintained its primitive innocence.'
Rogelio Villareal

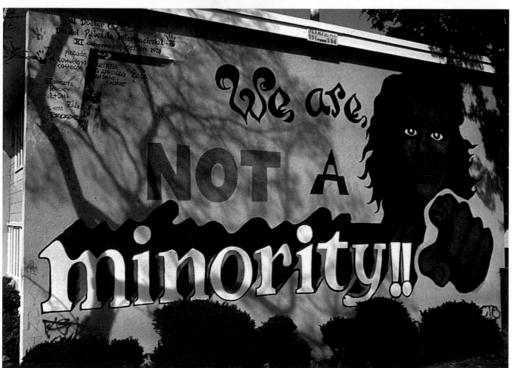

Top left: *Our America, with the sunshine of your courage, at your orders, Commandante!* EZLN (Ejército Zapatista de Liberación Nacional), August 2003. Raúl Ortega, Mexico. Courtesy of the photographer.
Below left: *We are not a minority!*, 1978. Estrada Courts Housing Project, East Los Angeles, CA. Painted by Mario Torero, photograph by Shifra Goldman. The original version of this mural was vandalized. This is the second version, repainted with a darker-faced Che.
Right: *Fidel Castro Speaks in Front of a TV Monitor on the 20th Anniversary of Che Guevara's Death*, 1987. Santiago de Cuba, Cuba. René Burri, Magnum Photos.

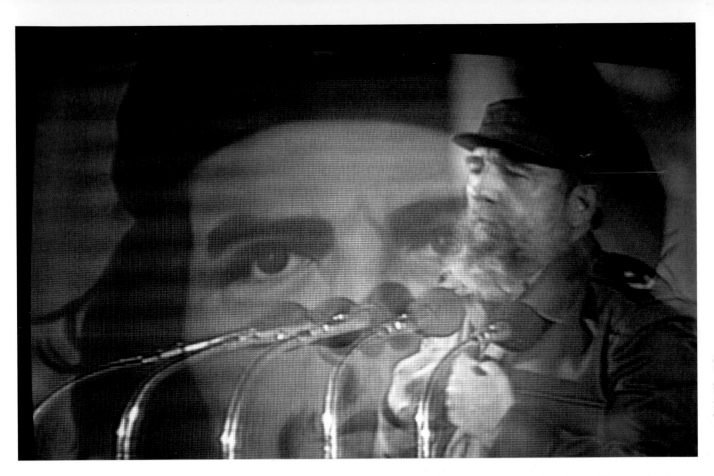

'The death of Che – as we said
a few days ago – is a hard blow, a
tremendous blow for the revolu-
tionary movement because it
deprives it, without a doubt, of its
most experienced and able leader.
But those who boast of victory
are mistaken. They are mistaken
when they think that his death is
the end of his ideas, the end of
his tactics, the end of his guerrilla
concepts, the end of his theory.
For the person who fell, as a
mortal person, as a person who
faced bullets time and again, as a
soldier, as a leader, was a
thousand times more able than
those who killed him by a stroke
of luck.'
Fidel Castro, excerpt from a
speech given on 18 October 1967,
Havana, Cuba.
Reprinted from *Che – A Memoir*
by Fidel Castro, 1994.

Above: **Enrique Agramonte, date unknown. Cuba.**
Top right: **Che in Midst of Battlefield, c. 1996. Huy Toan and Tran Huu Chat, Vietnam. Watercolour, 78 x 106 cm. Center for the Study of Political Graphics, Los Angeles.**
Below right: **10th anniversary of Ejército Zapatista de Liberación Nacional (EZLN), 1 January 2004. Raúl Ortega, Mexico. Courtesy of the photographer.**

'The guerrilla band is an armed nucleus, the fighting vanguard of the people. It draws its great force from the mass of the people themselves. The guerrilla band is not to be considered inferior to the army against which it fights simply because it is inferior in firepower. Guerrilla warfare is used by the side which is supported by a majority but which possesses a much smaller number of arms for use in defence against oppression.'
Che Guevara,
Guerrilla Warfare, 1960.

'We will never know what would have been the outcome had the revolution triumphed in the Congo and Bolivia. We must remember Che's eternal sentence: "How wonderful had it been to have had two or three more Vietnams with its sequels of blood and death!"'
Rogelio Villareal.

'Che was the revolutionary as rock star. Korda, as a fashion photographer, sensed that instinctively, and caught it. Before then, the Nazis were the only political movement to understand the power of glamour and sexual charisma, and exploit it. The Communists never got it. Then you have the Cuban revolution, and into this void come these macho guys with their straggly hair and beards and big-dick glamour, and suddenly Norman Mailer and all the radical chic crowd are creaming their jeans. Che had them in the palm of his hand, and he knew it. What he didn't know, of course, was how much that image would define him.'
Lawrence Osborne,
New York Observer, 2003.

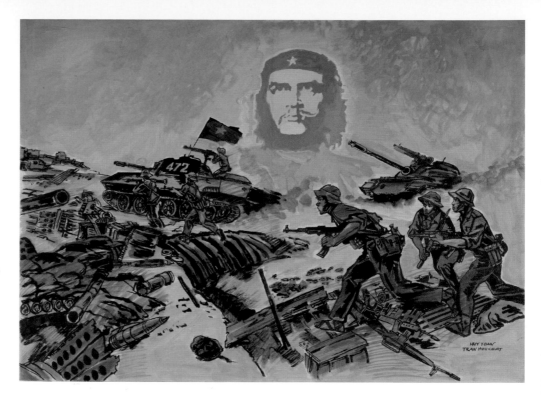

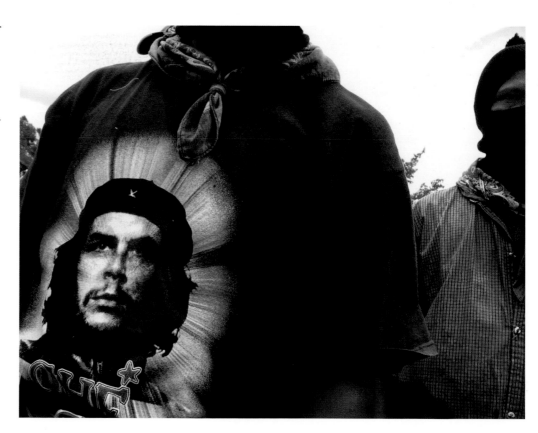

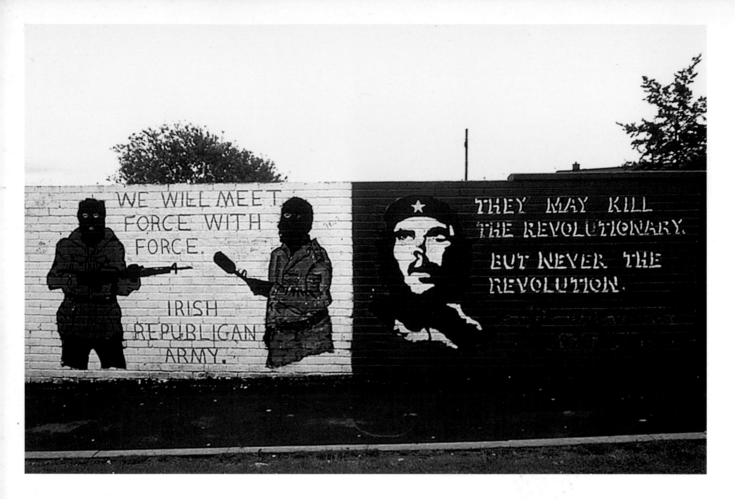

Untitled, 1980s. Artist unknown; photograph by James Prigoff, 1994. Strabane, Northern Ireland. The slogan is based on a quote from Che that first appeared in 1981 on a mural on Rockville Street, West Belfast, in the middle of the Hunger Strike. Che was born in Buenos Aires in 1928, the first child of Ernesto Guevara Lynch and Celia de la Serna. However, Ernesto Guevara Lynch's mother, Ana Isabel Lynch, with whom Che's family lived for years and to whom Che grew especially close, was the daughter of immigrants who – one version states – had sailed to Argentina from County Galway, Ireland, at around the time of the Irish Famine. According to another account, his grandmother was Irish-American from San Francisco. As a white Argentinean descended from local nobility on his mother's side, Che lived among the more privileged ranks of his country's class- and race-conscious society. The family plantation was lost after a series of poor investments made by Che's father, and the family was forced to move into a fifth-floor apartment with Ana Isabel Lynch. It was in these years that Che grew close to his grandmother.

POP

POP ART IS A REJECTION OF
TRADITIONAL FIGURATION,
RHETORIC AND RENDITION. ITS
EGALITARIAN ANTI-ART STANCE
WAS THE PERFECT COROLLARY
FOR CHE'S ANTI-ESTABLISHMENT
ATTITUDE.
JONATHAN GREEN

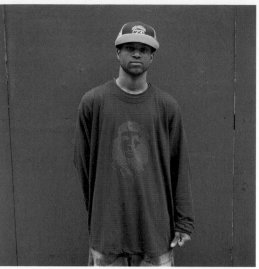

"'Ironically, Che's life has been emptied of the meaning he would have wanted it to have," asserts Jorge Castañeda, author of Compañero: The Life and Death of Che Guevara. *"Whatever the left might think, he has long since ceased to be an ideological and political figure." Castañeda insists, though, that Che still possesses "an extraordinary relevance. He's a symbol of a time when people died heroically for what they believed in. People don't do that any more."*

Christopher Hitchens (author and political journalist) believes that Che endures not because of how he lived, but how he died. "He belongs more to the romantic tradition than the revolutionary one. To endure as a romantic icon, one must not just die young, but die hopelessly. Che fulfils both criteria. When one thinks of Che as a hero, it is more in terms of Byron than Marx."'
Sean O'Hagan,
Observer, 11 July 2004.

Top: **Kevin Williams, New York City, April 2005. Photograph by Steve Pyke.**
Left: **Por la Ruta del Che (On the path of Che), 1988. Rafael López Castro and Gabriela Rodriguez, Mexico. March for Latin American Student Solidarity, 29 June – 26 July 1988. Offset litho, 33.4 x 21.6 in. Center for the Study for Political Graphics, Los Angeles.**

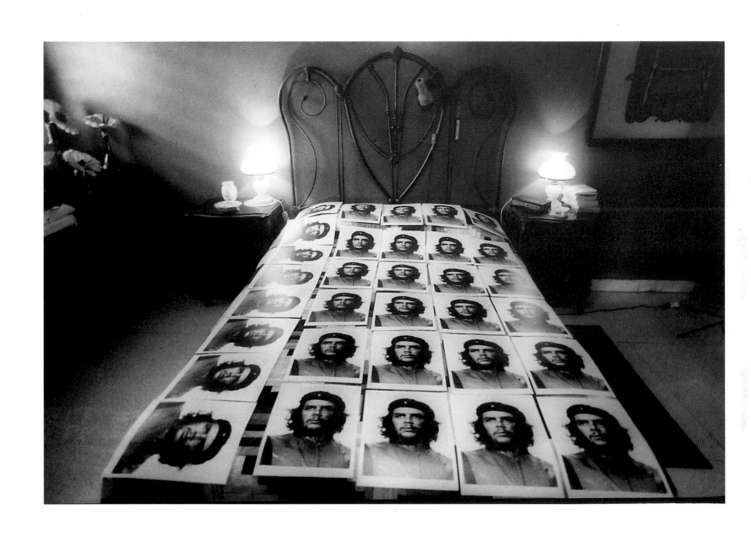

Vedado, La Habana, 1992.
José Figueroa, Havana, Cuba.
Courtesy of the photographer and
the Couturier Gallery, Los Angeles.

Left: ***Bobby Ras' Che***, 2004.
Douglas McCulloh.
**'This is a sequence of Bobby Ras
adding yet another Che to the
world under a street light at the
corner of Hollywood Boulevard and
Orange Drive (appropriately
right across the street from the
spot where Marilyn had her first
commercial photo shoot at the
Roosevelt Hotel swimming pool).
Bobby worked from a T-shirt.
I shot the T-shirt with the permis-
sion of the obliging owner. Bobby
did a rough reference sketch from
my camera's LCD screen, then
I took a sequence as he whipped
up his Che over four minutes.'
Douglas McCulloh.**
Right: ***'Warhol' Che*** **(original, 1968)
attributed to Gerard Malanga, Italy.
Reproduction, 2000. 84 x 71 cm.
Courtesy of Trisha Ziff.**

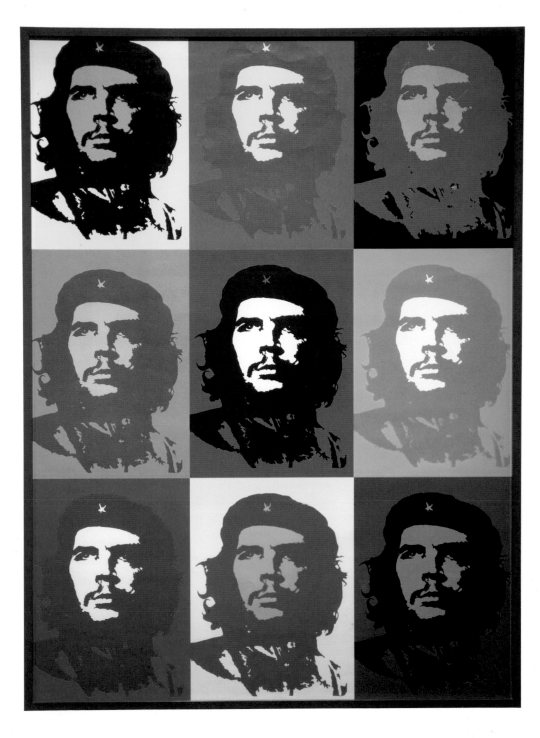

'While in Rome, Malanga, running short on money, forged a series of "Warhols" – silk-screen images based on a news photograph of the dead Cuban leader Che Guevara. He made two phony paintings, gave one to a girlfriend and offered the other for sale – priced at $3,000 – through a Rome gallery; in a February 1968 exhibition at that gallery, he also showed signed and numbered silk-screen prints from an edition of fifty, priced at fifty dollars. When the dealer sought to verify the provenance of the "Warhol" Guevaras, Malanga wrote to Warhol, explaining that if the works were not authenticated, Malanga would be "denounced – Italian style" and thrown into jail. Malanga enclosed a newspaper review of the show, commenting, "Andy, this is the first time that your artwork has been praised by the Communist press." "What nerve!" Warhol remarked. Not one to be outwitted, he wired back, authenticating the paintings but stipulating that all monies were to be sent directly to him as "Mr Malanga was not authorized to sell the artwork".'
David Bourdon, *Warhol as Filmmaker*, 1971.

'Dec 8, 2004.

*Dear Miss Ziff,
On behalf of Gerard Malanga, I am responding to your e-mail regarding the history of the Korda Che image which you refer to. I assume you are referring to the photographer, Signor Korda. The Che image that you enquire about has nothing whatsoever to do with Mr Korda's photograph, and for the record Mr Malanga has never "forged a series of Warhols". Mr Malanga cannot verify Mr Bourdon's recollection as being accurate.*

Wishing you all the best with your exhibit.

*Yours sincerely,
William Barnes,
Mr Malanga's business mgr.'*

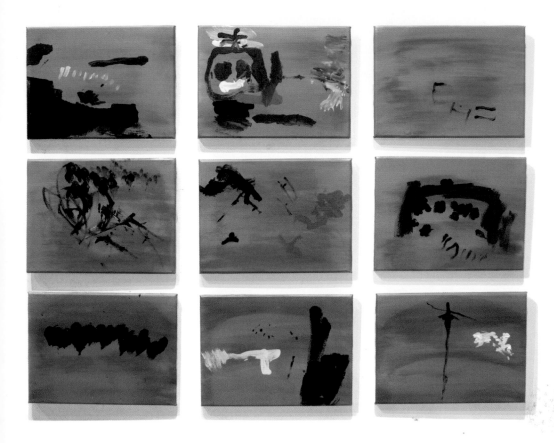

Fénix. Homenaje a Raúl Martínez,
2001. José Angel Toirac, Cuba. Oil on
canvas: 9 panels each 30.5 x 40.5 cm.
Gallery 106, Austin, Texas.
'The idea of Che as a role model
was approached in the small-sized
paintings series by the title
Fénix, Homenaje a Raúl Martínez
(Phoenix, a homage to Raúl
Martínez). I made this series with
the help of my son Mario Jorge.
Then about five years old, he was
just starting his school life. As
you can see, behind the coloured
spots in each painting the image
of Che is repeated, almost unseen:
a homage to Raúl Martínez,
who was the very first artist to
work with the image in Cuba and
associated it with the phoenix.'
José Angel Toirac, notes from
the artist.

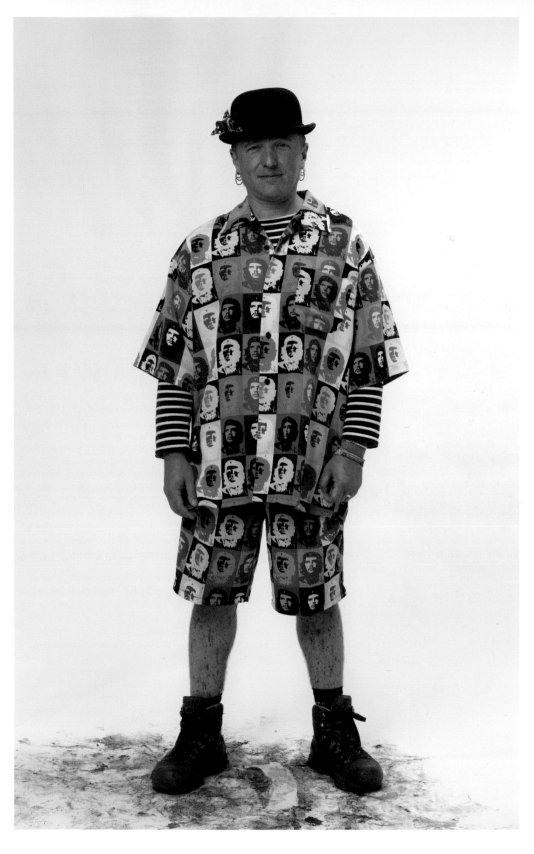

'Pop Art itself is a rejection of traditional figuration, rhetoric, and rendition. Its egalitarian anti-art stance was the perfect corollary for Che's anti-establishment attitude. Pop's depersonalization and standardization simplified Che's image and helped align him with the masses, at the same time certifying his image as everyman. Traditional art relished ambiguity, chance, introspection and the logic of uncertainty. Pop's aesthetic pushed towards absolutely unambiguous and uninflected meaning and repeatability. Warholian Pop deals with outlines and surfaces rather than full chiaroscuro. This reduction of the real world provided the perfect vehicle for distancing the image from the complexities and ambiguities of actual life and the reduction of the political into stereotype. Che lives in these images as an ideal abstraction.'
Jonathan Green.

Pinball Jerry, Glastonbury, 2005.
Barry Lewis. Courtesy of the photographer.

*'I'm just living out the
American dream
And I just realized that nothing
Is what it seems'*
Madonna, *American Life*.

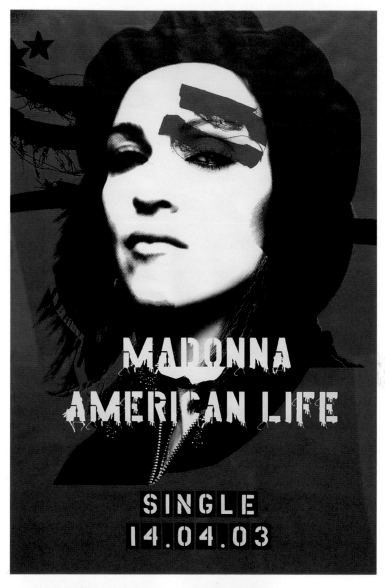

Madonna, American Life poster, 2003. 77 x 59 cm. Purchased on eBay, Japan, 2004.
Madonna's reinvention of her own image plays purposefully with the historic image of 'Tania' (below left), the *nom de guerre* of Haydee Tamara Bunke Bider, who died in a 1967 ambush in Bolivia at the age of 29. Her remains were found in 1998 within a mile of those of Che Guevara. In the best-known photograph of Tania, she is wearing the same type of beret as Che Guevara. Madonna's image picks up from both the wearing of the beret and the gaze of Che in the Korda photograph. Arguably the image of 'Tania' resonates with those of other beret-wearing rebel images, both real and fictional, for example that of Faye Dunaway as Bonnie in *Bonnie and Clyde* (below middle), which was released in 1967, the year of Tania's death. The 'Tania' image was echoed and referenced in the 1974 image of newspaper heiress Patty Hearst (below right), who took on the name 'Tania' while active in the Symbionese Liberation Army (SLA). In the case of Madonna her only action is to wear the beret, and in doing so she successfully manipulates the iconic value of the beret for her own gain, in her latest reincarnation.

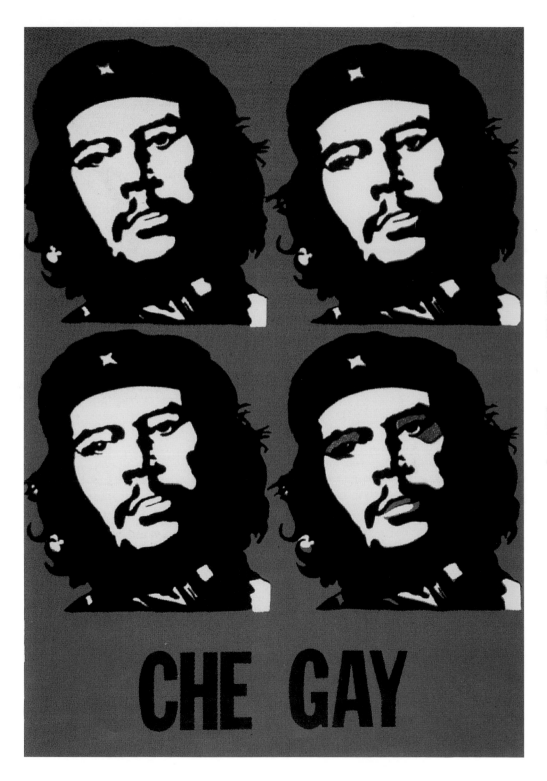

Che Gay, 1974 (original).
Artist unknown, UK. Digital copy
of an offset print. 77 x 60 cm.
Collection of Instituut voor Sociale
Geschiedenis, Amsterdam and
Center for the Study of Political
Graphics, Los Angeles.

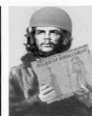
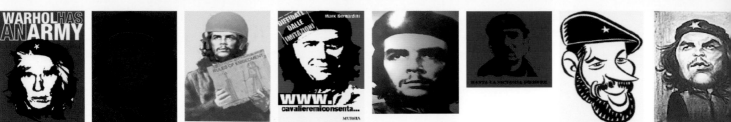
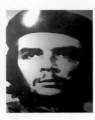

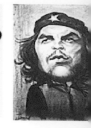

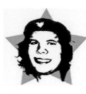

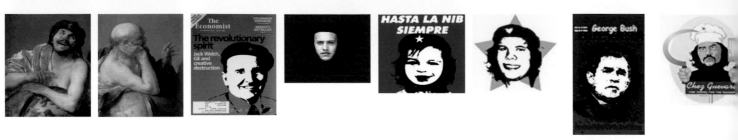

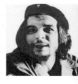
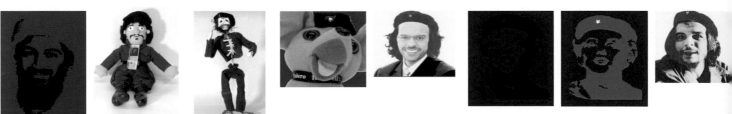

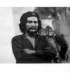
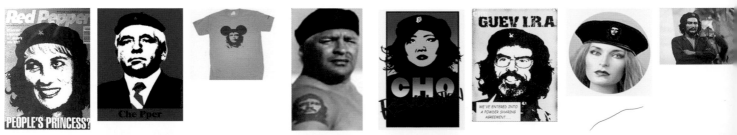

 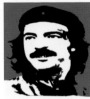 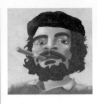 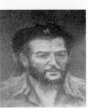 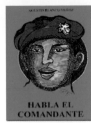

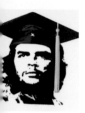

Че Бояра

HABLA EL COMANDANTE

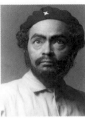

Meek. Mild. As if

SOFTWARE LIBRE

 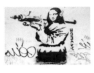 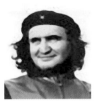

LITTLE CHE

AFFA

 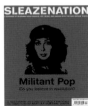

CHE GUEVARA

NOAM

SLEAZENATION

Militant Pop

 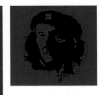 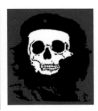

21

Where's the Brain

¡CHE!

 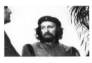

VIVA LA REAGAN REVOLUCION

Che lookalikes, taken from the web.
Courtesy Jonathan Green,
California Museum of Photography,
UC Riverside, CA.

CHESUCRISTO

I AM NO CHRIST, NOR A PHILAN-
THROPIST. I AM THE VERY
OPPOSITE OF CHRIST... I WILL
FIGHT WITH ALL THE ARMS WITHIN
REACH INSTEAD OF LETTING
MYSELF BE NAILED TO A CROSS.
CHE GUEVARA

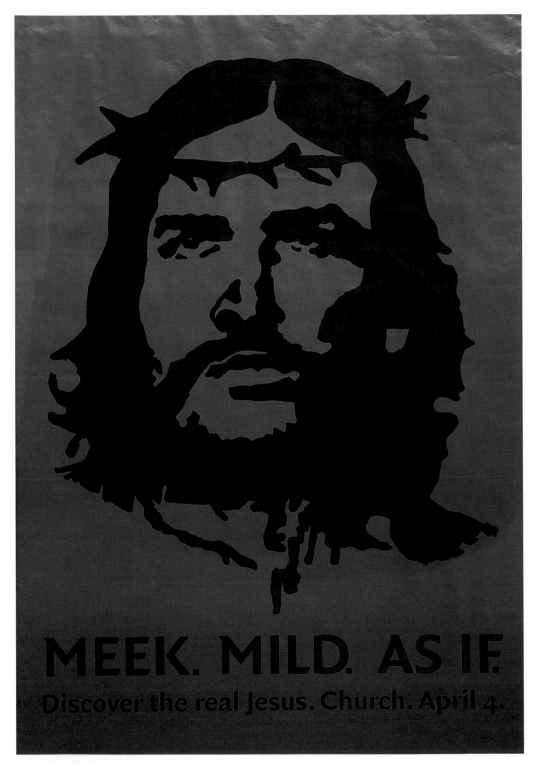

MEEK. MILD. AS IF.
Discover the real Jesus. Church. April 4.

Jesus: No Wimp in a Nightie, 1999.
Bus shelter poster, UK. Collection of David Kunzle. 152 x 101 cm.
'A poster depicting Jesus Christ as a Che Guevara-style revolutionary has been launched by Christians to entice more people into church. The Church Advertising Network (CAN) stated that it modelled its poster on the ubiquitous image of the beret-wearing revolutionary to dispel the notion that Jesus is "a wimp in a nightie".

The Rev. Peter Owen-Jones of CAN, who used to work in advertising, conceded the image on the poster might shock some traditional churchgoers. "We are not saying that Jesus was a communist, but that he was a revolutionary. We are exploiting the image of revolution, not the image of Che Guevara," he said. Dr William Beaver, spokesperson and Communications Director of the Church of England, denounced the campaign as in "no way, shape or form" appropriate. A *Daily Mail* editorial was in "despair" over the promotion of "such offensive, dishonest and ignorant rubbish", as described in a *Los Angeles Times* article, Jan 7 1999. The London *Independent* similarly on Jan 7 1999 quoted the Bishop of Wakefield, who criticized the association of Jesus with Che, suggesting it "trivialized the mystery of the godhead". Predictably, objections were raised that Jesus was not a political revolutionary.'
Excerpt from BBC report, 5 January 1999, taken from research on this theme by David Kunzle.

FUSION: CHRIST AND CHE David Kunzle

'Hoy hay que impedirte de ser Dios' (Now we have to prevent you from being God), graffito on ceiling beam in a washroom of the Vallegrande hospital where Che's body was exposed.

A major reason why, of the thousands of pictures taken of Che in life and death, Korda's has attained supremacy, is its Christ-like nature. The British Churches' advertising campaign recognized this in their controversial fusion (FIG). Of all the photographs of Che, Korda's best express-es Christian ideas of inspiration, hope, serenity and timelessness. But Korda's was not the first 'Christ-like Che' to be made public: the dead Che, as seen by local visitors 'in the life' and as photographed for the world in Vallegrande, first sparked the mythic association, and the idea of immor-tality. Soon thereafter, the public was ready for the 'other' photograph: a Che-Christ very much alive, after the Che-Christ liter-ally dead and figuratively alive. The reach and intensity of the gaze in the Korda photograph are unique, as are the circum-stances in which it was taken: mourning and anger over a cruel mass death – a Jesus contemplating human iniquity.

The fusion of Korda's Che with Christ involves the accretion of some very specific, symbolic characteristics in art. Since Siqueiros painted the Latin American Indian crucified in Los Angeles in 1932, the identification of the Latin American with Christ's Passion has been endemic. The Cross may be that of the International Monetary Fund and Foreign Debt; the crucified Christ may be called 'the Crucifixion of Central America'; and in the Cuban posters for the revolutionary priest and martyr Camilo Torres, cross and gun were fused. The gun is now gone, as we have seen; in the huge *Imagen Constante* exhibition of Che portraits solicited from all over the world (Havana, 1997), only the North Koreans offered a rifle, in the upraised hand of a stern Korda Che. Now we see, in Cuban murals, posters and art, mostly doves and flowers, demands for peace with justice, common to convent-ional Christian iconography.

The Star, a universal as well as Christian symbol, is ubiquitous with Che, radiating from his beret in divine, polychrome light, guiding us, leading us, rising in multiples of celestial thought around the globe (Rostgaard, Raúl Martínez). It explodes into a fiery furnace in a La Paz university mural, and burns literally in metres-high flames at Cuban celebrations. The star of Che is monumentalized in aluminium sculpture in a Havana Youth centre – but it also represents, in a Cuban critical light, the unattainability of Che, and his submer-sion by consumerism.

The letters CHE, often as a signature, are treated in art today as formerly the sacred trio IHS (Latin acronym for Jesus, Saviour of Man), as icons in themselves. The Halo, the saint: in the Korda photo-graph the beret functions subliminally as a flattened halo. Che, with regular halo, takes his place with other 'secular saints' of Latin America, and as St George and the

generic, supernatural tutelary figure; but in a *Spiegel* cover, he is old, worried and his halo is composed of bullets. The crown of thorns is replaced by the crown of stars, and barbed wire; the last photo of Che alive, hands bound, is analogized to an Ecce Homo. The star becomes holy stigmata on the hand, and a jeans jacket button-hole evokes the wound in Jesus's side. Che replaces Jesus in a Last Supper in a Stanford University student dormitory; and the Crucifixion is re-enacted with a naked Che as Jesus, in a contemporary setting, by a Nicaraguan primitivist painter.

Deposition/pieta: 'He was like a Christ taken down from the Cross…' (Peter Weiss). The exhibition of Che's body in Vallegrande, October 1967, intended to prove to the world that the world's most famous revolutionary was indeed dead, had the opposite effect: it made Che seem alive, to resurrect. Sight of the emaciated, bullet-ridden body reminded locals, from doctors to peasants, and sight of the photographs reminded people worldwide of Jesus taken down from the Cross. A slightly fore-shortened Freddy Alborta photograph in particular evoked the classic dead Christ by Mantegna, and Holbein, and Rembrandt's sub-Christian *Anatomy Lesson of Dr Tulp*. A shot of Che's head, eyes staring uncannily, brought him back to life, and as the image (as conceived by an Argentine painter) of the Christ-face imprinted on the sacred shroud of Turin. An artist of Vallegrande has the crucified Jesus look down upon Che, in wonder and pity.

There have been specific symbolic references to Christ's Passion in film and video: in Richard Dindo's *Bolivian Diaries,* Roger Spottiswoode's *Under Fire* (via the Vallegrande photographs), and Leandro Katz's *El Dia que me quieras,* based entirely on the photographs. Cuban installation artist José Toirac's *Requiem* (2004) is a quasi-religious meditation on Che's body. His *Reliquias que nunca vimos* (Relics we never saw), features casts of the face and cut-off hands of Che 'the mythic Delegate or Son of God'; his *Hecho in Manila* (1998*)* is manifestly Christ-eucharistic, 'the body of the hero offered for food,' and his *El Alma, El Cuerpo, Transubstanción* makes multiple references to the New Testament: the Betrayal, the Ascension, the incredulity of St Thomas.[1]

A verbal graphic from Bolivia called *Nails as Bullets* in honor of Che and Nestór Paz Zamora, a Christian mystic and guerrillero of Bolivia, is thus configured:

Clavos Como Balas

Nestór
Clavados los ví en la guerrilla
ernesto
erchesto
ercresto
ercristo
el cristo.

1. See Meira Marrero, 'Ars Longa, Vita Brevis,' in Toirac, *Mediaciones*, Havana 2001

'The resemblance to aspects of Christ's life on earth can be easily traced in the life of Che. Both were doctors – Christ as miracle healer, Che as the trained physician, and were active as such, even or especially so when they were fighting, doctoring when others were resting or escaping. Both men were particularly concerned with leprosy, the disease of the downtrodden and outcast, as The Motorcycle Diaries (books and film) have reminded us in the case of Che. Like Che, Jesus was an egalitarian, a communist in terms of owning little and sharing all, and his disciples were bidden to hold all in common. Both were strict disciplinarians, who insisted on individuals leaving families, friends and privileges behind to join them, sacrificing comforts and, if need be, their own lives. Said a comrade, Borrego, of Che, quoted by John Lee Anderson, "He was superstrict, like Jesus Christ."'
David Kunzle, 1997.

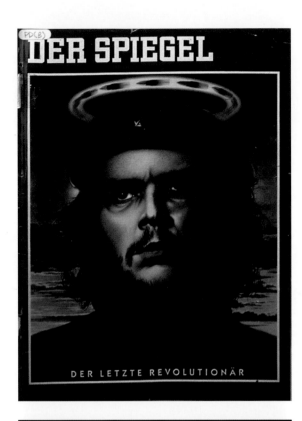

DER SPIEGEL

DER LETZTE REVOLUTIONÄR

Che Guevara

'Jesus of Nazareth vs Che Guevara

Last weekend, The Motorcycle Diaries started in our cinemas. It's a movie about the young Che Guevara and his adventures while travelling around South America. The tagline to this movie is "Let the world change you… and you can change the world". Did Che change the world? I would say no. Other people did, like someone who lived two thousand years ago and also travelled around a lot. His name was Jesus and I thought it would be interesting to compare these two people. A lot of people think of Che as some kind of savior, just like Jesus, but I think these two men couldn't be any more different. Where Che used force and even killed people to reach his goals, Jesus used the power of words. Jesus changed much more, just by using words.'
Extract from a blog: http://www.cyberexorcism.com/2004/11/jesus-of-nazareth-vs-che-guevara.html, posted by Giovanni Aureel.

'The halo sanctifies, in the first instance, before it christifies. On the Spiegel cover, which imagines Che grown old and careworn, the halo is with deliberate, discreet ambiguity studded with bullets; in the T-shirt version these bullets are further elided to resemble decoration. A series of wood sculptures called En el Mar de América by Alejandro Aguilera shows a file of crudely worked "saints", Bartolomé de las Casas, Don Quixote, Bolívar, José Martí and Che, all haloed.'
David Kunzle, 1997.

Top: **Myth of Che Guevara. Der Spiegel, no. 38, 16 September 1996. Collection of David Kunzle.** Left: **T-shirt, derivative of the Der Spiegel magazine cover, with halo surrounded by moving bullets. Collection of David Kunzle.**

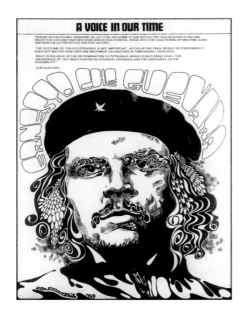

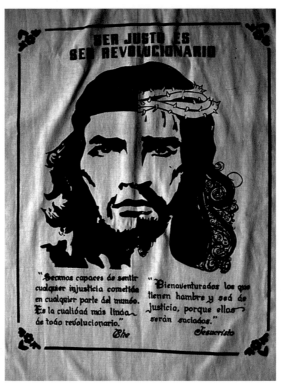

Top left: *A Voice in Our Time*, 1968.
Jim Fitzpatrick, Ireland. Silkscreen
print, 76 x 50.5 cm.
Collection of the artist.
Top right: Chesucristo T-shirt, 2003.
Athens, Greece.
Collection of David Kunzle.
Bottom: *Untitled*, date unknown.
Raúl Martinez, Cuba. Work
on paper, 57 x 39 cm. Drawing for
wood sculpture reproduced in
Kunzle, 1997, p. 83. Courtesy of
José Veigas, Cuba.

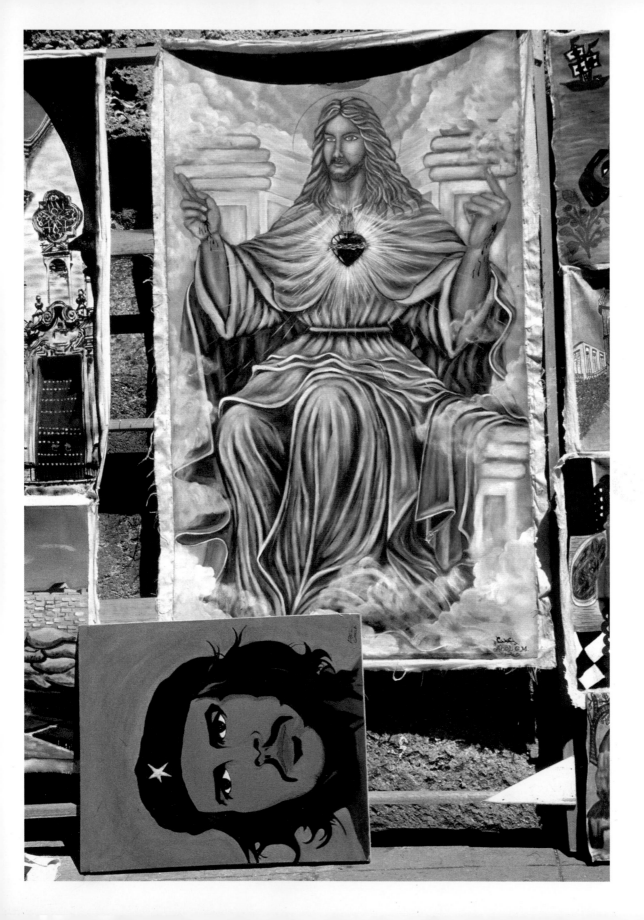

'Hello Santana

I have been informed by our friend Raul Artiles that you will soon be presenting yourself in Miami, something I believe is not recommendable. I bring this forth to you because not long ago you clumsily appeared at the Oscar awards wearing a crucifix over a T-shirt with the stereotyped image of the "Carnicerito de la Cabaña" (Little Butcher of the Fortress). This is how Che Guevara is known to the Cubans that had to agonize with this character in that prison. One of these Cubans was my cousin Bebo, precisely a convict in this jail for merely being a Christian. He always retells with sourness about the times at dawn when Christian prisoners were killed without mercy screaming "Hail Jesus King!"…. Furthermore, it is an insult and a slap in the face to those young Cubans from the sixties who had to hide away in order to listen to your "imperialist music".'

Paquito D'Rivera, Cuban jazz artist, Miami; extract from an open letter to musician Carlos Santana, who was to give a concert in that city.

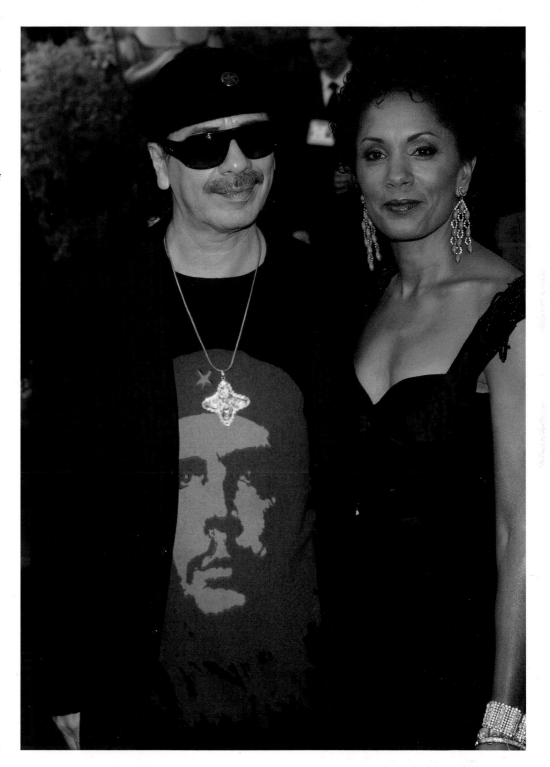

Left: *Untitled*, **1997. Havana, Cuba. Abbas, Magnum Photos.**
Right: **Carlos Santana wears Korda Che with crucifix to the Oscars, pictured with his wife Debra at the 77th Academy Awards, Hollywood, 27 February 2005. Courtesy EMPICS.**

'In some respects, Jesus was treated better than Che. He got a trial, or a form of a trial. His body, after execution, was taken down and left to the care of his loved ones to mourn and inter; whereas Che was exposed to public shame, his body desecrated (his hands amputated), then hidden. Like Jesus's, his body disappeared, for thirty years. Not even his own brother, with legal rights to its disposal, was allowed to see it, much less take it, and just as with Jesus, there were some who could not believe he was really dead.'
David Kunzle, 1997.

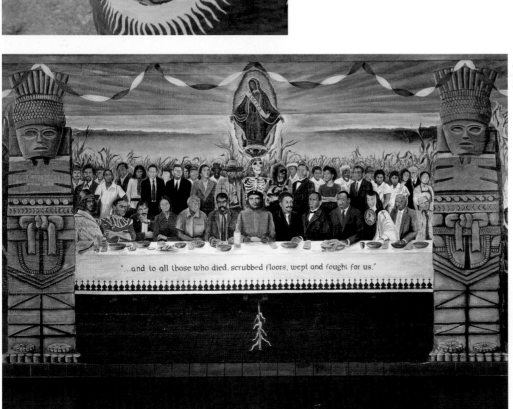

Top: *Untitled*, date unknown. Ernesto Ramírez, Oventic, Chiapas, Mexico. Courtesy of the photographer
Bottom: *Last Supper of Chicano Heroes*, 1989. José Antonio Burciaga. Reproduction of an 8 x 15-metre mural at Stanford University, California. Offset print. Center for the Study of Political Graphics, Los Angeles.

'The heroes in this mural in the Chicano-themed Casa Zapata dormitory at Stanford were selected through a poll the artist conducted amongst students, faculty and staff. The Virgin of Guadalupe, patroness of the Americas and the spiritual hero-ine of Mexican and Chicano culture, did not place first but was positioned above out of respect. Leading the poll was Che Guevara, who replaces Christ. Other heroes at the table include Benito Juárez, Dr Martin Luther King, Emiliano Zapata, César Chávez, Dolores Huerta, Frida Kahlo, Joaquín Murieta and Augusto Sandino. On the tablecloth is the additional dedication from one student's hero list: and to all those who died, scrubbed floors, wept and fought for us [so that I could be here at Stanford].'
David Kunzle, 1997.

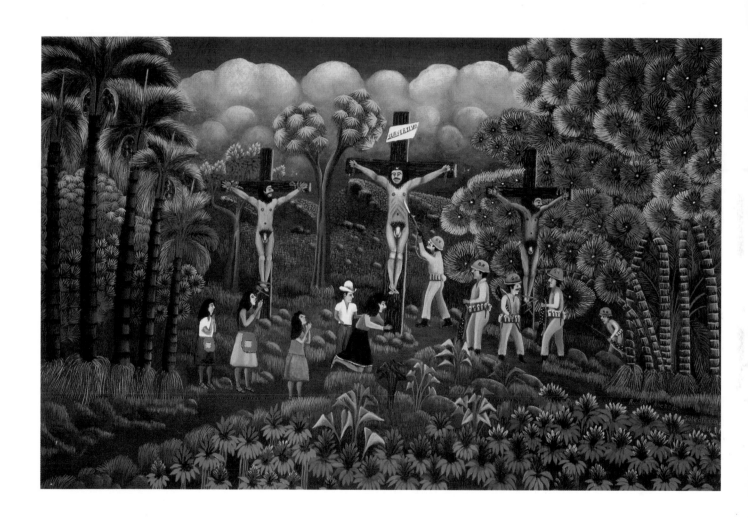

Che Dies on the Cross, 1980s.
Raúl Arellano, Nicaragua. Offset
print, 49.5 x 69.5 cm. Center for the
Study of Political Graphics, Los
Angeles. The soldiers on the right
have GN on their helmets, represen-
ting Samosa's National Guard.
The people praying on the left are
Nicaraguan peasants, set in a
'primitive' Nicaraguan landscape.

EMBLEM

HAS THE ONCE FEARSOME
REVOLUTIONARY BEEN REDUCED
TO A HARMLESS ICON? THE
CORPORATE WORLD, ADEPT AT
CO-OPTATION, WOULD HAVE
US THINK SO.
DAVID KUNZLE

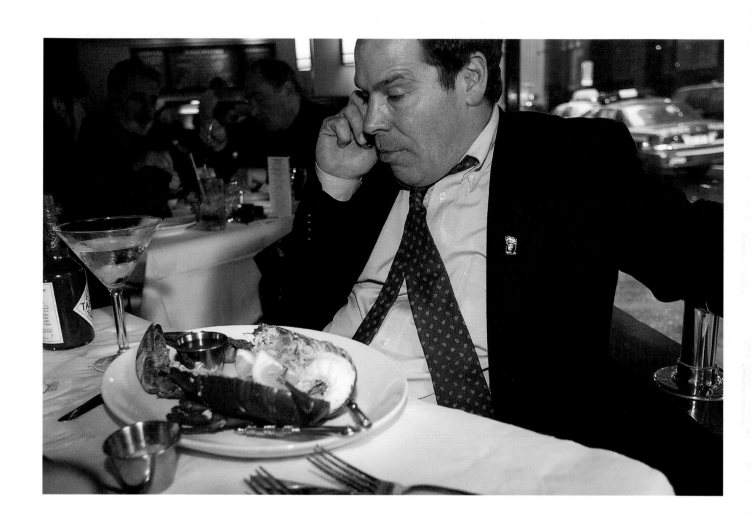

*Randy Credico, stand-up
comedian, and Rockefeller drug
law activist eat dinner at Docs
restaurant in New York City*, 27 April
2005, Shana Wittenwyler/Veras.

This page: *Fernando Rubén Brodsky, mi hermano, secuestrado el 14 de agosto de 1979, y desaparecido desde entonces* **(Fernando Ruben Brodsky, my brother, was kidnapped on 14 August 1979, and is still lost, 2003). Marcelo Brodsky, Argentina. Triptych: three inkjet prints. Courtesy of the photographer.**
Above: ***Fernando in our room*, Buenos Aires, 1968.**
'This picture of Fernando is one of the first I took in my life, with an antique camera my dad gave me. We are in the room we shared. His face is blurry. His movements, today non-existent, diffuse him before the lens. The photographs on the wall, however, bear the lengthy exposure better. It is the best picture I have left of him, of when we lived together.'
Marcelo Brodsky

Left: ***Fernando on vacation in Chile with Che T-shirt*, Viña del Mar, Chile, 1972.**
Above: ***Fernando at the ESMA*, Buenos Aires, 1979. Photograph by Victor Basterra.**
'This is the last picture of Fernando. It was taken in the concentration camp of the School of Mechanics of the Navy (ESMA). It was shot by Victor Basterra, a kidnapped photographer who worked for the military, taking portraits of the prisoners. He managed to take some negatives out of the ESMA, among them this one. He testified with them in the Trial of the Juntas and these photographs were very important proofs of what had happened.'
Marcelo Brodsky

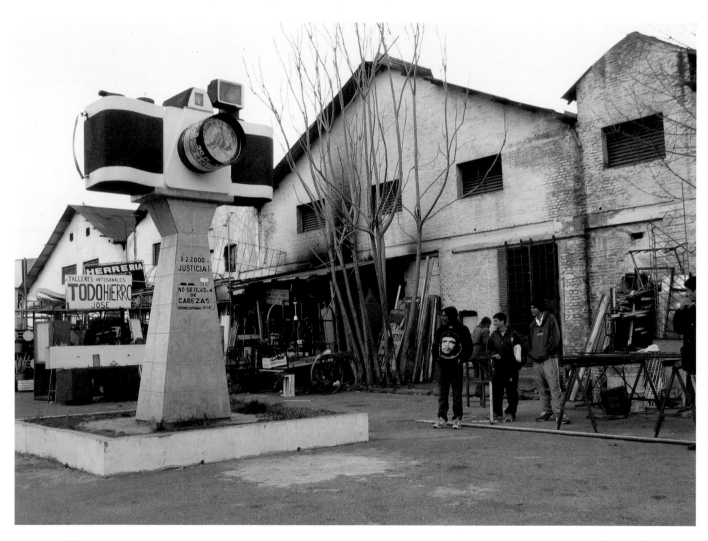

Memorial to Assassinated Photojournalist José Luis Cabezas, 2003. John R. Harris, Buenos Aires, Argentina. Courtesy of the photographer.
On 25 January 1997, news photographer José Luis Cabezas was brutally tortured and murdered at Pinamar, Argentina's most exclusive beach resort. He was a photographer for *Noticias*, the country's leading news magazine, and an investigative journalist involved in uncovering issues of corruption.

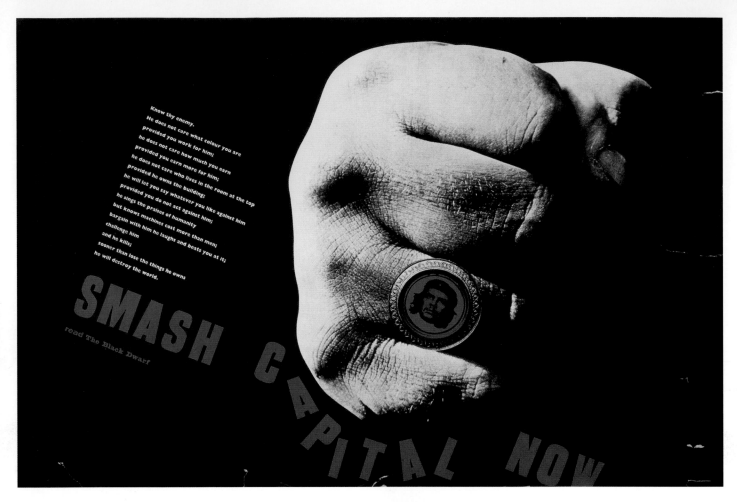

Know thy enemy.
He does not care what colour you are
provided you work for him;
he does not care how much you earn
provided you earn more for him;
he does not care who lives in the room at the top
provided he owns the building;
he will let you say whatever you like against him
provided you do not act against him
he sings the praises of humanity
but knows machines cost more than men;
bargain with him he laughs and beats you at it;
challenge him
and he kills;
sooner than lose the things he owns
he will destroy the world.

SMASH CAPITAL NOW

read The Black Dwarf

'Mike Tyson has attacked journalists outside a hotel in Cuba, according to witnesses. The boxer, holidaying on the Caribbean island, was furious when he emerged from a lift in one of Havana's premier sea-front hotels on Tuesday to see five reporters waiting for him. Tyson, wearing jeans but no top and sporting a tattoo of Latin American guerrilla hero Ernesto "Che" Guevara on his stomach, raised his fists in a threatening gesture and yelled insults in English and Spanish.'
BBC Report, 2 January 2002.

Above: *Smash Capital Now*, 1970s. Poster for The Black Dwarf. Artist unknown, UK. Silkscreen print, 56 x 86 cm. Center for the Study of Political Graphics, Los Angeles. Left: **Mike Tyson weighing in. Postcard, photographer and date unknown.**

Above: **Che perro**, El Rincón, La
Habana, Cuba, 2003. *Un peregrino
cumple una promesa a San Lazar.*
Francisco Mata Rosas, Mexico.
Right: **Untitled**, 2003. **Raúl Ortega,
San Cristóbal de las Casas,
Chiapas, Mexico. Courtesy of the
photographer.**

Liberating the Church, c. 1970.
Artist unknown, Photo Riehl,
Germany. Offset print, 83 x 59.5 cm.
Center for the Study of Political
Graphics, Los Angeles.
This image appeared originally on
the cover of the German satirical
magazine *Pardon*, in its December
1969 issue, in association with a
report about radical elements within
the Catholic Church. The poster was
co-published by Dutch poster
company Verkerke Reprodukties
and *Pardon*.

Semana Santa (Holy Week), 1999.
Seville, Spain.
Carl de Keyzer, Magnum Photos.

'The famous image is not venerated by all. It has also been aged, laughed about, parodied, insulted and distorted around the world. Che's holy look has been covered with spit and eggs, just as the National Lampoon's *front page*. It has literally been transformed into one of the worst symbols and reconstructed by publicists, traders, artists and people in show business. There have been those that are insulted because others wear the Che-pillín T-shirt, a comical derivative that blends Che with a famous performer, a Mexican clown.'
Rogelio Villareal.

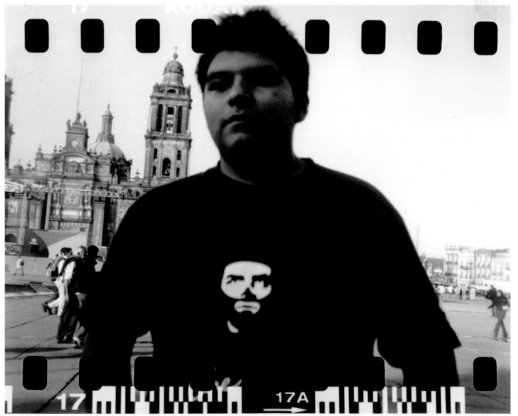

Top: *Che's Tattoo*, 2002. Yolanda Andrade, Mexico City, Mexico. Courtesy of the photographer.
Left: *Che-pillín*, Mexican TV comic, 2003. José Antonio Salas, Mexico City. Courtesy of the photographer.

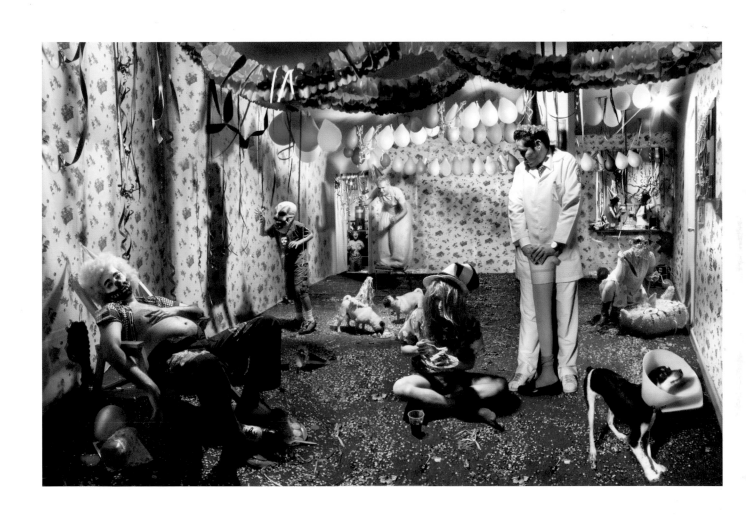

Queremos Pastel
(We want cake), 2005. Fernando
Montiel Klint, Mexico City.

'The main task at hand was getting to Iquitos…. The first person we hit on was the mayor, someone called Cohen; we had heard a lot about him, that he was Jewish as far as money was concerned but a good sort. There was no doubt he was tightfisted; the problem was whether he was a good sort. He palmed us off to the shipping agents, who in turn sent us to speak with the captain, who was kindly enough, promising the huge concession of charging us third-class fares and letting us travel in first. We weren't happy with this…. Then the second-in-command… promised to help…. [Later] we came across him, [and] he said he's secured a great deal for us: as a special favour to him, the captain had agreed to charge us third-class fares and let us travel in first. Big deal.'
Che Guevara,
The Motorcycle Diaries.

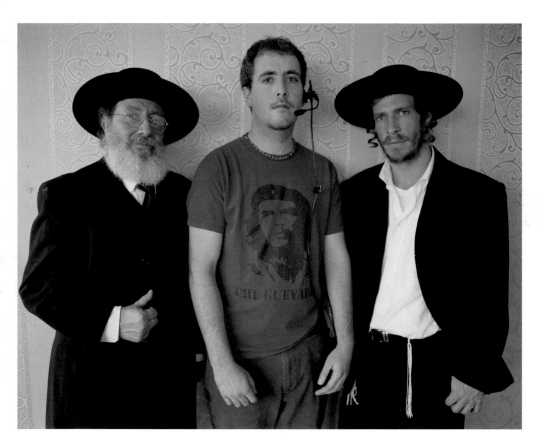

Above: ***Che Guevara Judeu*,
Latuff, Brazil, 2003.**
Left: **On the set, *Morirse está en hebreo* (Dying in Hebrew), 2005.
Director Alejandro Springall.
Dante Busquets, Mexico City.
Courtesy Springall Pictures.**

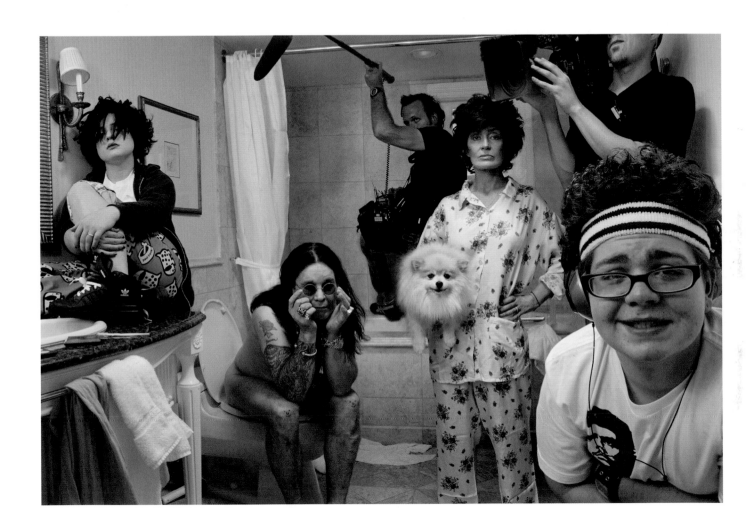

**The Osbournes: Kelly, Ozzy,
Sharon, and Jack Osbourne.**
**The Beverly Hills Hotel, California,
7 October 2002.**
Annie Leibovitz for *Vanity Fair*.
Courtesy of Contact Press Images.

'Does Che survive only as a T-shirt icon? The big media and many Che biographers have stressed the kitschification of Che, the former with glee, the latter with regret. Has the once fearsome revolutionary been reduced to a harmless icon? The corporate world, adept at co-optation, would have us think so. Rather, I would say the "real" Che has not died, but undergone a tactical shift.'
David Kunzle, 1997.

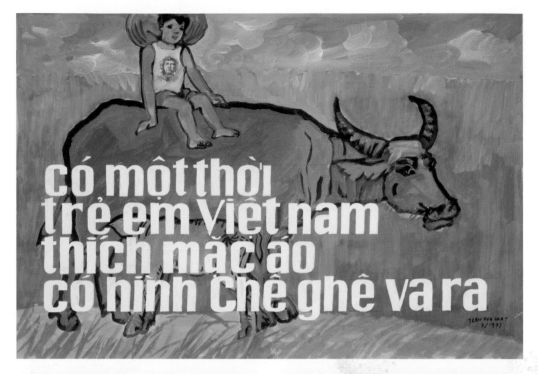

Top: *Có một thò'l*, 1997. Tran Huu Chat, Vietnam. Gouache, 55 x 77 cm. Center for the Study of Political Graphics, Los Angeles
Bottom left: *Pumas Che*. Los Pumas soccer team, Mexico City, 2005. Courtesy Estela Treviño.
Bottom right: Diego Maradona, official T-shirt, 2004. Buenos Aires, Argentina. Purchased on eBay.

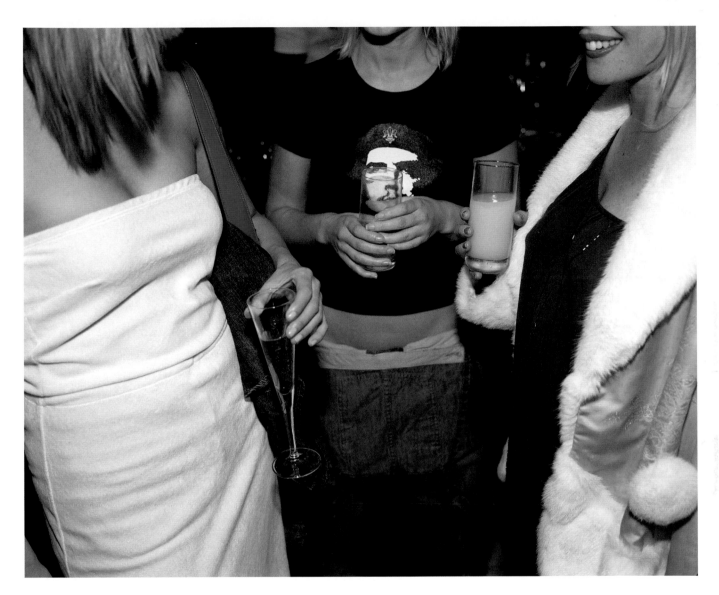

'Deep inside that T-shirt where we
have tried to trap him, the eyes
of Che Guevara are still burning
with impatience.'
Ariel Dorfman, *Time*, 14 June 1999.

**Opening of the Saatchi Gallery,
housed in the Former County Hall,
London, 15 April 2003.
Martin Parr, Magnum Photos.**

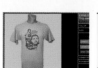
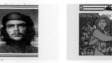

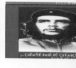

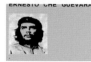

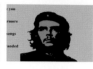
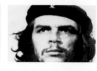
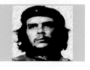

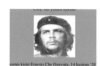

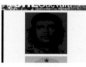

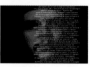

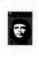

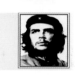

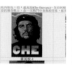

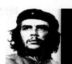

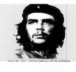

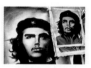

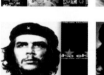
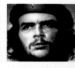

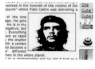
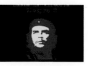
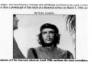

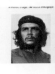

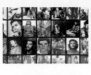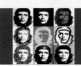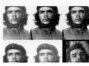
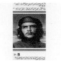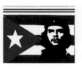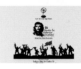
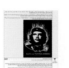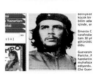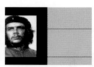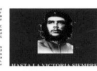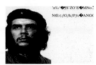
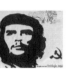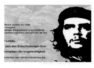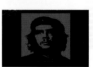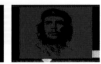
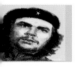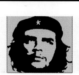

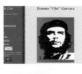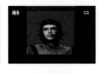
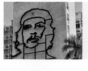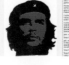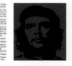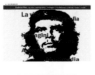
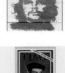

**Frame grab websites featuring
the Korda Che image.
Collected by Jonathan Green
and Trisha Ziff, 2004–5.**

SELLOUT

TODAY, CHE LIVES! ALL RIGHT,
BUT NOT IN THE WAY HE OR HIS
FELLOW REVOLUTIONARIES
COULD EVER HAVE IMAGINED IN
THEIR WORST NIGHTMARES. HE
HAS BECOME A GLOBAL BRAND.
SEAN O'HAGAN

ICE CREAM WITH CHOCOLATE, CHERRY SAUCE AND COMPOUND CHOCOLATE

INGREDIENTS: CANE SUGAR, WATER, CREAM, CONCENTRATED SKIM MILK, FRUIT JUICE (CHERRY (6%), GRAPE (2%)), VEGETABLE SHORTENING, COCOA BUTTER, MILK SOLIDS, COCOA MASS, COCOA, VEGETABLE GUMS (407, 410, 415, 1442), EMULSIFIERS (471, SOYBEAN LECITHIN), FLAVOURS, COLOURS (124, 160b).
MADE IN AUSTRALIA (NSW). STREETS ICE CREAM, 20-22 CAMBRIDGE STREET, EPPING, NSW 2121 AUSTRALIA. 486 JACKSON STREET, PETONE, NEW ZEALAND. STREETS GUARANTEE THE QUALITY OF THIS PRODUCT. IF YOU HAVE ANY COMMENTS, PLEASE CALL OUR CUSTOMER SERVICE CENTRE 1800 643 336 (AUSTRALIA), 0800 446 250 (NEW ZEALAND) DURING BUSINESS HOURS ONLY, OR WRITE TO THE ADDRESS SHOWN.
® MAGNUM IS A REGISTERED TRADEMARK. ™ STREETS AND THE SIXTIES NINE ARE TRADEMARKS.
MANUFACTURED ON MACHINERY THAT ALSO MANUFACTURES PRODUCTS WHICH CONTAIN PEANUTS AND/OR OTHER NUTS.
ICE CREAM PORTION CONTAINS 10% MILKFAT MINIMUM

MAGNUM ®
CHERRY GUEVARA

MAGNUM ™
CHERRY GUEVARA

The revolutionary struggle of the cherries was squashed as
they were trapped between two layers of chocolate.
May their memor...

9 310016 801661

MAGNUM ™
CHERRY GUEVARA

The revolutionary struggle of the cherries was squashed as
they were trapped between two layers of chocolate.
May their memory live on in your mouth!

9 310016 801661

CENTRE 1800 643 336 (AUSTRALIA), 0800 446 250 (NEW ZEALAND) DURING BUSINESS HOURS ONLY, OR WRITE TO THE ADDRESS SHOWN.
® MAGNUM IS A REGISTERED TRADEMARK. ™ STREETS AND THE SIXTIES NINE ARE TRADEMARKS.
MANUFACTURED ON MACHINERY THAT ALSO MANUFACTURES PRODUCTS WHICH CONTAIN PEANUTS AND/OR OTHER NUTS.
ICE CREAM PORTION CONTAINS 10% MILKFAT MINIMUM

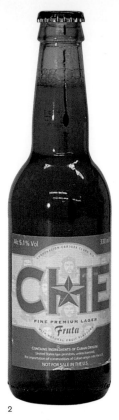

2

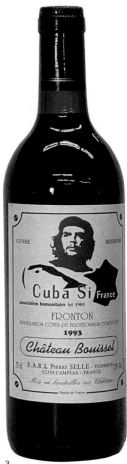

3

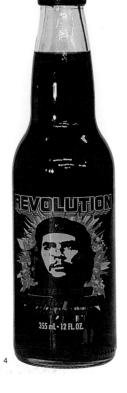

4

5

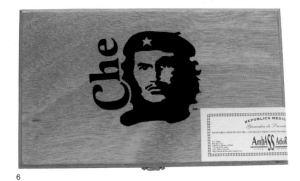

6

7

8

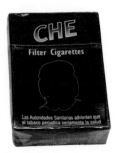

9

1 (previous page): ***Cherry Guevara***, **date unknown. Magnum Ice Cream, Australia. From the series** ***The Sixties Nine***. **Collection of David Kunzle.**

'The revolutionary struggle of the cherries was squashed as they were trapped between two layers of chocolate. May their memory live on in your mouth!' Magnum Ice Cream, Australia.

2: *CHE*, Fine Premium Lager, UK, date unknown. Cuban ingredients, not for sale in the United States. Collection of David Kunzle.

3: *Cuba Si* Cuvée reserve, 1993. Chateau Bouissel, France. Association Humanitaire. Collection of David Kunzle.

4: *Revolution*, rebel red cream soda, Canada. Collection of David Kunzle.

5: Sniff tissues. Washington DC, 2005. Courtesy Cinda Rosenberg.

6: Mexican cigar box and cigar, 2004. eBay Mexico.

7: Found condom, 2005, Mexico City.

8: French cover for cigarette packet, Paris, France, 2004. Collection Trisha Ziff.

9: *Che* filter cigarettes, Barcelona, 2004. eBay España.

'Perhaps in these orphaned times of incessantly shifting identities and alliances, the fantasy of an adventurer who changed countries and crossed borders and broke down limits without once betraying his basic loyalties provides the restless youth of our era with an optimal combination, grounding them in a fierce centre of moral gravity while simultaneously appealing to their contemporary nomadic impulse. To those who will never follow in his footsteps, submerged as they are in a world of cynicism, self-interest and frantic consumption, nothing could be more vicariously gratifying than Che's disdain for material comfort and everyday desires. One might suggest that it is Che's distance, the apparent impossibility of duplicating his life anymore, that makes him so attractive. And is not Che, with his hippie hair and wispy revolutionary beard, the perfect postmodern conduit to the nonconformist, seditious '60s, that disruptive past confined to gesture and fashion? Is it conceivable that one of the only two Latin Americans to make it onto Time's 100 most important figures of the century can be comfortably transmogrified into a symbol of rebellion precisely because he is no longer dangerous?'
Ariel Dorfman
http://www.time.com/time/time100/heroes/profile/guevara03.html

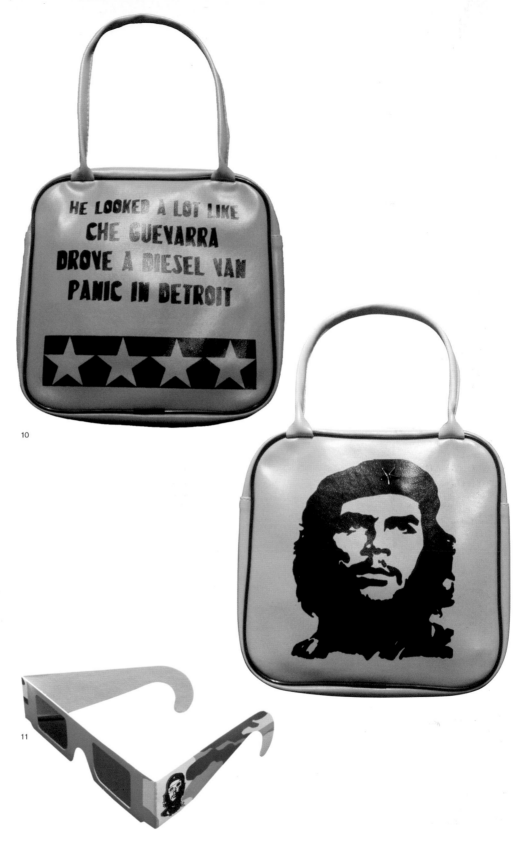

10

10: Bag (front and back) purchased in Los Angeles, 2005.

'He looked a lot like Che Guevara
Drove a diesel van
Kept his gun in quiet seclusion.
Such a humble man
The only survivor
Of the national people's gang.'
David Bowie, *Panic in Detroit*.

11: *Che's Chevy (Remix) 3D glasses*, 2000. Rubén Ortiz Torres. From the 3-D video *Zamba del Che*, which includes a customized dancing low-rider 1960 Chevy Impala. Commissioned by the Getty Museum, Los Angeles, California.

11

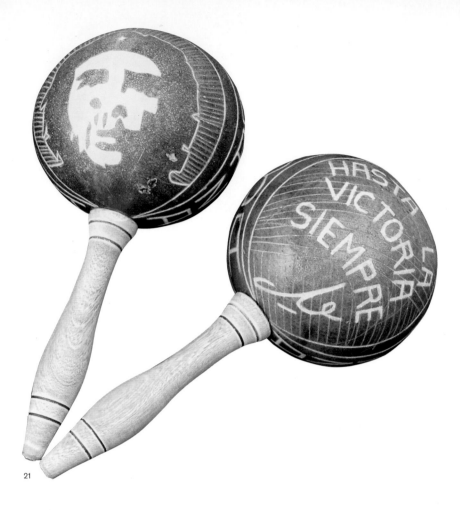

12

21

13 14 15 16 17 18 19 20

12–20: **Collection of Che badges, 1990–2004. Cuba, France, USA, Mexico, Spain. Collection of David Kunzle.**
21–22: **Tourist memorabilia purchased in Cuba, 1996. Maracas and miniature guitar with box. Collection of David Kunzle.**

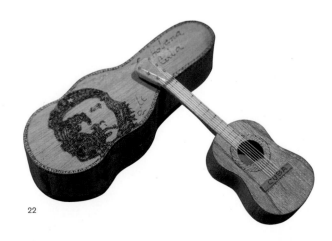

22

23

'Popular fast food ads featuring
a talking Chihuahua hawking
Taco Bell products have offended
some members of Miami's Cuban
exile community who think the
latest commercial glorifies leftist
revolutionary Ernesto "Che"
Guevara.

The most recent in a series of
ads starring the dog with big ears
and bulging eyes has him posing
as a beret-wearing revolutionary
who appears before a crowd in a
public square and says "Viva
Gorditas," sending onlookers into
a cheering frenzy.

Some members of Miami's
800,000-strong Cuban exile
community interpreted the ad as a
parody of the stage play and movie
"Evita" and saw the Chihuahua
as Guevara…Taco Bell vice
president Peter Stack said the ads
were meant to portray revolution
"generically" and did not seek
to glorify any revolutionary figure.
In tests on Hispanic audiences, he
said, the response was "over-
whelmingly positive."

"The advertising is about our
revolutionary taco," Stack said.
"It's about Gordita-ism and not
any other kind of 'ism' out there."'
Excerpt from MIAMI (Reuters)
1998. Copyright 1998 Reuters
Limited. All rights reserved.

24

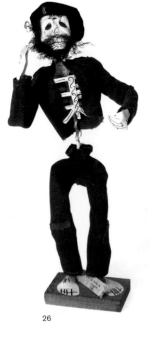

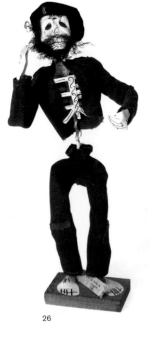

25

26

23: *Taco Bell Chihuahua*, 1988.
Publicity campaign.
Collection of David Kunzle.
24: DeCals collected from a journey
through Latin America, 1970s.
Courtesy of Ed Grazda.
25: Commandante Che Metrushka
doll, 2003. Moscow, Russia. Five
nested dolls. Based on photographs
of Che by Alberto Korda and René
Burri. eBay Russia.
26: *El Che*, Day of the Dead figure,
Coyoacan, Mexico City, 2003.
Collection of Pedro Meyer.

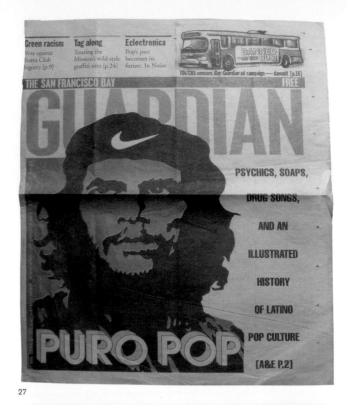

Green racism Vote against Sierra Club bigotry [p.9]

Tag along Touring the Mission's wild-style graffiti sites [p.24]

Eclectronica Pop's past becomes its future. In Noise

TDI/CBS censors *Bay Guardian* ad campaign — damnit [p.18]

BANNED ON THE BUS!

THE SAN FRANCISCO BAY

FREE

GUARDIAN

PSYCHICS, SOAPS, DRUG SONGS, AND AN ILLUSTRATED HISTORY OF LATINO POP CULTURE [A&E P.2]

PURO POP

STEAL THIS MAG!!

POCHO! MAGAZINE

POCHO NUMERO 9

$3.50 IN AZTLÁN AND THE OUTER TERRITORIES

FOUND!: CHE'S FUNNY BONES

#9 FEATURES: DIANA CRASH PHOTOS! EL NINO INTERVIEW! SANCHEZ SEPTUPLETS! THE BECK DIARIES! ANDY'S BOYS! ROC EN ESL! Y MUCHO MUCHO MORE!

A TSUNAMI OF SATIRE the EL NINE-O ISSUE

POCHO 9 SP 98 $3.50

Is Nothing Sacred?

Son-o'-God Comics · Dead-Kitten Calendar · R. Crumb Rip-Off

Plus: Uncalled-For Attacks & Pointless Insults

NATIONAL LAMPOON

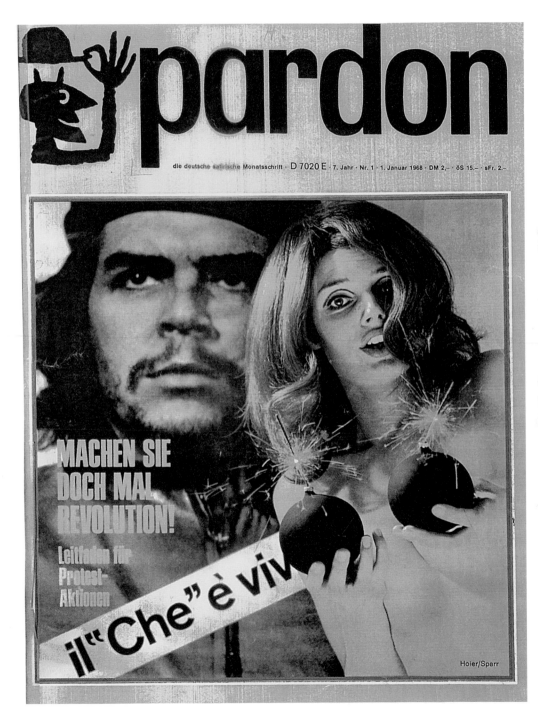

pardon

die deutsche satirische Monatsschrift · D 7020 E · 7. Jahr · Nr. 1 · 1. Januar 1968 · DM 2,– · öS 15.– · sFr. 2.–

MACHEN SIE
DOCH MAL
REVOLUTION!

Leitfaden für
Protest-
Aktionen

il "Che" è viv

Hoier/Sparr

27: *San Francisco Bay Guardian*,
March 1993.
Collection of David Kunzle.
28: *Pocho!*, **issue no. 9. Published in**
Aztlán and the Outer Territories.
Collection of David Kunzle.
29: *National Lampoon*, **vol. 1, no. 22,**
January 1972.
Collection of Trisha Ziff.
30: *Pardon*, **January 1968. Hoier and**
Sparr. Center for the Study of
Political Graphics, Los Angeles.

30

31

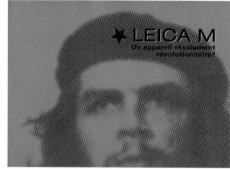

32

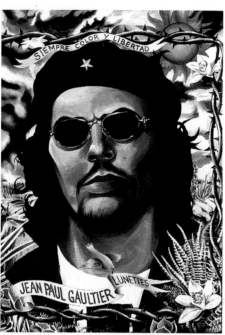

33

34

31: *The Spirit of Che lives in the new Evergreen!* Poster designed by Kenneth Dearoff after the painting by Paul Davis and used as a magazine cover for *Evergreen Review* (February 1968).
The first time the image is published in the USA. Inspired (says the artist) by pictures of Italian martyred saints and the resurrected Christ, he has idealized, romanticized and sensualized his Korda model. The poster was formatted to fit New York subway billboards (see page 22).

32: Leica Manual: *How Revolutionary Should your Camera Be?* Leica, Germany, 1999. Collection of David Kunzle.

33: Sunglasses advertisement, 1999. Jean Paul Gaultier, Paris.

34: *Radio Rebelde*, 1958–1982. Artist unknown, Cuba. Offset print, 58 x 41 cm. Center for the Study of Political Graphics, Los Angeles.

'To use the image of Che Guevara
to sell vodka is a slur on his name
and memory.'
Alberto Korda, photographer.

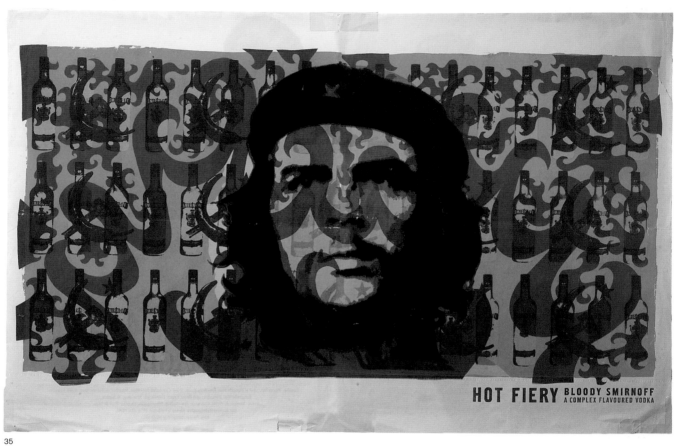

35

35: **Smirnoff Vodka advertisement,
2000. Collection of David Kunzle.**

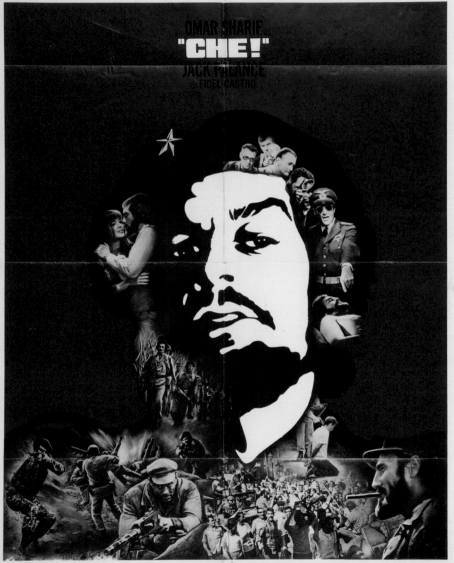

36: *Omar Sharif as 'Che'*, 1969. Artist unknown, United States. Poster for Twentieth Century Fox Film Corporation. Offset print, 104 x 68.5 cm. Center for the Study of Political Graphics, Los Angeles.
37: *Five Dollar Bill*, 1990. Pedro Meyer, Mexico. Inkjet print. Courtesy of the photographer.

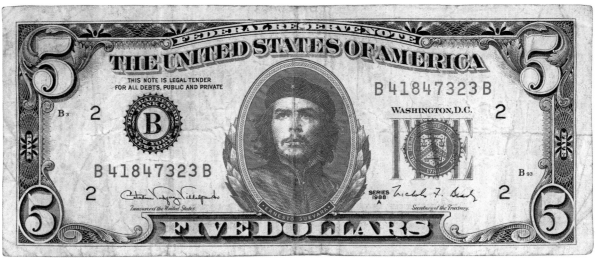

37

14 June 1928
Ernesto Guevara Lynch is born in Rosario, Argentina, into a liberal, middle-class family. He is the first of five children and suffers from asthma.

1947
Guevara studies medicine at the University of Buenos Aires.

1951–2
Guevara travels in Argentina. He meets the lepers at Cordoba and goes to Chile, Peru, Colombia, Venezuela and Miami where he is turned back by the US immigration authorities. In Peru he works in the San Pablo leprosarium. These experiences have an impact on the development of his political thought, later described in his journal, *Motorcycle Diaries.*

1953
Guevara completes his medical degree and travels to Bolivia and Guatemala. After supporting the resistance against the coup in Guatemala, Guevara flees to Mexico City, works in the General Hospital and teaches on the medical faculty of the National University (UNAM).

1955
In Mexico, Guevara meets Fidel Castro, the Cuban revolutionary in exile.

1956
Castro forms the 26th of July Revolutionary Movement. Guevara joins the group as a medic. The group of 82 land on the coast of Oriente Province (in the east of Cuba). On 2 December they launch an attack against the Batista regime, resulting in the death or capture of most of their comrades; 12 survive, including Castro, his brother Raul and Guevara. They retreat to the Sierra Maestra mountains and stage continuous attacks against the Batista government.

1957
Guevara is made commander of one of the five guerrilla columns.

1958
Guevara leads the guerrilla advance from Oriente Province through government lines to central Las Villas Province. Guevara's column takes the strategic provincial capital of Santa Clara in the centre of Cuba on

28 December. The road to Havana is now clear.

1959
Batista flees the country on New Year's Day. Castro's 3,000 guerrillas have defeated a 30,000-strong professional army. Guevara enters Havana on 2 January. A new interim government is formed and is recognized by the US on 7 January. Castro assumes the position of prime minister on 16 February. Guevara is declared a Cuban national. He marries his second wife, Aleida.

7 October 1959
Guevara is appointed Director of the industrialization programme of the National Agrarian Reform Institute. The agency administers land reforms and the expropriation of American-owned businesses and agricultural estates.

26 November 1959
Guevara is made President of the National Bank of Cuba.

5 March 1960
Alberto 'Korda' Díaz takes iconic image, *Guerrillero Heroico.*

August 1960
Time magazine cover story calls Guevara 'Castro's brain'.

October 1960 to February 1961
Guevara tours socialist and communist countries, including Czechoslovakia, the Soviet Union and China.

January 1961
The US officially breaks diplomatic relations with Cuba.

23 February 1961
Guevara is appointed Minister of Industry in the Cuban government, stepping down from his position as President of the National Bank.

17 April 1961
1,300 Cuban exiles, supported by the CIA and operating from a base in Nicaragua, attempt to invade Cuba at a southern coastal area called the Bay of Pigs.

1962
US extends the trade restrictions on Cuba. The 'Cuban Missile Crisis' flares in October when the US Government discovers that the Soviet Union is setting up launch sites in Cuba for long-range ballistic missiles.

1964
Tensions within the Cuban government over Guevara's economic policies continue and are heightened by his enthusiasm for carrying the revolution beyond Cuba into other parts of Latin America and to Africa.

March 1964
Guevara represents Cuba at a UN conference on trade and development. He travels to Beijing, Paris, Algeria and Moscow.

1965
Guevara, still on the move, travels to the Congo, Guinea, Ghana, Dahomey (Benin, West Africa), Algiers, Paris, Tanzania and Beijing. In February, while addressing the Tricontinental Conference at Algiers, he hints at his disillusionment with the established socialist countries.

April 1965
Guevara tells Castro he is relinquishing all his official positions and his Cuban nationality. In July travels to the Congo with a group of Cuban volunteers to foment a rebellion.

3 October 1965
Castro publicly reads a farewell letter written by Guevara in April. 'I feel that I have fulfilled the part of my duty that tied me to the Cuban revolution in its territory,' the letter says. 'And I say goodbye to you, the comrades, your people, who are already mine. Other nations of the world call for my modest efforts. I can do that which is denied you because of your responsibility as the head of Cuba, and the time has come for us to part.'

1966
Guevara returns to Cuba in March, but quickly travels on to Uruguay, Brazil, Paraguay, Argentina and Bolivia, where he becomes a leader of a communist guerrilla movement attempting to overthrow the Bolivian military government.

1967
The guerrilla band has some success but receives little support from local people. Never numbering more than 50 men and one woman, the guerrillas are soon outmanoeuvred by about 1,800 US-trained and CIA-armed Bolivian troops.

8 October 1967
Guevara is wounded and captured near Vallegrande, in the mountains of central Bolivia. He is carried to the village of La Higuera, 30 km southwest of Vallegrande, and placed under guard in a schoolhouse. Around noon the following day, Guevara is executed with four gunshots to his chest. His last words are reported to be, 'I know you have come to kill me. Shoot, coward, you are only going to kill a man.' Guevara is dead at the age of 39. Following the execution, Guevara's hands are removed so that his identity can be confirmed by fingerprinting.

11 October 1967
Guevara's handless body and the bodies of six of his executed colleagues are secretly buried near the airport at Vallegrande.

18 October 1967
Castro delivers a eulogy for Guevara to nearly a million people assembled in Havana's Plaza de la Revolución. Castro states that Guevara's example and ideals will be an inspiration for future generations of revolutionaries. 'They who sing victory over his death are mistaken,' Castro says. 'If we want to know how we want our children to be, we should say, with all our revolutionary mind and heart: we want them to be like Che.'

July 1995
A Bolivian general reveals the location of Guevara's grave.

July 1997
Guevara's body is exhumed and returned to Cuba. The thirtieth anniversary of his death is celebrated across Cuba.

2000
Time magazine names Guevara as one of the 100 most influential people of the twentieth century. 'Though communism may have lost its fire, he remains the potent symbol of rebellion and the alluring zeal of revolution.'

2004
In a bid to promote tourism in Bolivia the 'Che Trail' (la Ruta Che) is officially opened in the central highlands where Guevara spent his last days.

2004
The film *The Motorcycle Diaries,* directed by Brazilian Walter Salles, brings a new generation to see a fictional version of the young Che.

Today
The image of Korda's 'Che' has become iconic, globally for sale. Guevara has been subsumed by the capitalist consumer culture he despised.

Born 1928 Alberto Díaz Gutiérrez, Havana, Cuba. From 1946–50 he studied commerce at the Candler College, Havana, Cuba and went on to the Havana Business Academy. In 1956 he founded the Studio Korda on Calle 21 Vedado in Havana, having begun working full-time as a photographer. From 1959–62 he was a newspaper photographer for the Cuban daily paper *Revolución*, and personal photographer to Fidel Castro, whom he accompanied throughout the early years of the revolution. On 5 March 1960 Korda took the famous photograph of Che Guevara, *Guerrillero Heroico*. In 1961 Korda became a founding member of the Unión de Escritores y Artistas de Cuba (UNEA). From 1968–80 he was photographer for the Department of Marine Research with the Science Academy of Cuba.

During his lifetime Korda had over fifty solo exhibitions in Cuba and throughout the world, in countries as diverse as Norway, France, Germany, Spain, Mexico, the USA, Chile and Argentina. Korda's work has also appeared in numerous collective exhibitions throughout the world including *Shifting Tides: Cuban Photography after the Revolution*, shown in Los Angeles, New York, Chicago and Illinois. His famous image of Che, *Guerrillero Heroico,* is the subject of this book and the associated exhibition, touring to the USA, Mexico and UK. During his lifetime Alberto Korda won numerous awards and was the subject of many documentaries. The most recent film made about his life, *KordaVision*(2005), directed by Héctor Cruz Sandoval, has been shown at film festivals across the US and Europe and is currently under consideration for nomination in the documentary category for the 2006 Oscars.

Korda died in Paris at the age of 72 on 25 May 2001. He was buried in Havana on 29 May 2001.

Books on Che

Imagery

Camnitzer, Luis, *New Art of Cuba,*
Texas, 2003.
Cushing, Lionel, *Revolucion!: Cuban
Poster Art,* San Francisco, 2003.
Kunzle, David, *Che Guevara: Icon,
Myth and Message,* Los Angeles, 1997.
Wride, Tim B., Cristina Vives and Wan
Wenders, *Shifting Tides: Cuban
Photography After the Revolution,*
New York, 2001.

Biographies of Che

Anderson, Jon Lee, *Che Guevara:
A Revolutionary Life,* New York, 1997.
Castañeda, Jorge G., *Companero:
The Life and Death of Che Guevara,*
New York, 1998.
James, David, *Che Guevara:
a Biography,* London, 1970.
Harris, Richard, *Death of Revolutionary,*
New York, 2000.
Sinclair, Andrew, *Che Guevara,*
New York, 1970.

Che's own writing

*The Motorcycle Diaries: Notes on a
Latin American Journey,*
with Cintio Vitier and Aleida Guevara,
Ocean Press, 2003.
Guerrilla Warfare, Nebraska, 1998.
The Bolivian Diary, New York, 1994.

Cuban history

Block, Holly, *Art Cuba: The New
Generation,* New York, 2001.
Chomsky, Aviva, Barry Carr and Pamela
Maria Snorkaloff, *The Cuba Reader:
History, Culture, Politics,*
Duke University, 2004.

**There are numerous websites and
blogs which look at Cuban art,
posters and culture, such as:**
http://www.zonezero.com
http://138.23.124.165/exhibitions/che/
default.html – California Museum of
Photography
http://www.politicalgraphics.org/home.
html – Center for the Study of Political
Graphics

Films on Che

*Una Foto Recorre el Mundo
(A Photograph Travels the World)*, 1981
Director: Pedro Chaskel
El Instituto Cubano del Arte e Industria
Cinematográphicos

KordaVision: A Cuban Revelation, 2004
Director: Héctor Cruz Sandoval

El Che: Investigating a Legend, 1997
Director: Maurice Dugowson
Produced by Cinéteve and Igeldo
Communications, White Star

Che!, 1969
Director: Richard Fleischer
A Sy Bartlett–Richard Fleischer
Production
20th Century Fox

The Motorcycle Diaries, 2004
Director: Walter Salles
Focus Features

Fidel A Showtime Original
Mini-series, 2002
Director: David Attwood
Showtime Networks Inc.

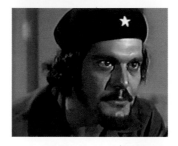

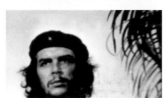

Notes on Contributors

The contributions of all below have been invaluable in the genesis of this book.

Hannah Charlton is a former journalist, editor and digital publisher, who is currently a communications and content specialist. After several years at *The Sunday Times*, she set up digital publishing for *News International*, producing over twenty CD-ROMS. Since then, she has had ten years of experience in that area, working for Bertelsmann, Pricewaterhouse Coopers and PAL, Britain's leading creativity lab. Most recently she spent a year at the Arts Council, developing a range of online communications and publications for Creative Partnerships. She is currently working with a range of organizations including photographers, publishers and curators as part of her creative solutions agency Neontree.

Jonathan Green is Director of the UCR/California Museum of Photography at the University of California, Riverside. Green is a photo-historian, curator, photographer and filmmaker. He was associate editor of *Aperture*, 1974–6. His books include *American Photography: A Critical History* (1984) and *Continuous Replay: the Photographs of Arnie Zane* (1999). Green received an NEA photographer's fellowship and his photographs are in museum collections around the world. Before coming to UC Riverside, Green directed the Creative Photography Laboratory at MIT and was the Founding Director of the Wexner Center for the Arts at Ohio State University. In 2005 at UCR/CMP, working with curator Trisha Ziff, Green produced the exhibition *Revolution and Commerce: the Legacy of Korda's Portrait of Che Guevara,* on which this book is based.

David Kunzle, Professor of Art History at UCLA, has written articles and books dealing with popular, political and public art, such as murals and comic strips, and the revolutionary art of Latin America. His books include *Che Guevara: Icon, Myth and Message* (1997), *The Murals of Revolutionary Nicaragua* (1995), *From Criminal to Courtier: the Soldier in Netherlandish Art 1550–1670* (2002), and an updated (2004) edition of *Fashion and Fetishism: the corset, tight-lacing and other forms of body-sculpture.* He is just finishing two books, a monograph and facsimile edition, on the comic strips of the father of the art, Rodolphe Topffer.

Rogelio Villarreal is a Mexican author and editor. Over the last two decades he has been responsible for the production of several Mexican counter-cultural magazines. On three occasions he worked as a contributing essayist on books for Smart Art Press, including *Double Trouble,* a book on Tom Patchett's collection. Currently he is contributing writer for several newspapers and cultural magazines, and editor-in-chief of *Replicante* magazine. His latest book *is El dilema de Bukowski* (2004)

Brian Wallis is Director of Exhibitions and Chief Curator at the International Center of Photography, where he organized the Larry Clark retrospective (2005), among other exhibitions, and co-organized *Young America: The Daguerreotypes of Southworth & Hawes* (2005), *Only Skin Deep: Changing Visions of the American Self* (2004), and *Strangers: the First ICP Triennial of Photography and Video* (2003). His publications include *Art Matters: How the Culture Wars Changed America* (1999); *Constructing Masculinity* (1995); *Blasted Allegories: Writings by Contemporary Artists* (1986); and *Art After Modernism: Rethinking Representation* (1984).

Trisha Ziff is an editor, independent curator and producer. She has curated six major international exhibitions in the last ten years. Her *Narrative of a Portrait: Korda's Che* has been shown at the Rencontres de la Photo in Arles and the California Museum of Photography, and will tour to the International Center of Photography in New York and the Victoria and Albert Museum, London. Her books include *Between Worlds: Contemporary Mexican Photography* (1990), *Distant Relations: Chicano, Irish and Mexican Art and Critical Writing* (1995) and *Hidden Truths: Bloody Sunday 1972* (1999). She is a Guggenheim scholar, and is currently co-producing a feature film in Mexico, *Morirse ésta en hebreo,* while finishing her doctoral thesis at the University of London.

Acknowledgements

Che Guevara: Revolutionary and Icon has been several years in production. I am indebted to the help of many people in Cuba, the United States, Mexico, France and England for making this book possible. In particular to David Kunzle for his generosity in sharing so much of his own research material and valuable time. This book builds on his important work.

I am also indebted to Jonathan Green, Director of the California Museum of Photography, who produced the accompanying exhibition in collaboration with me, for his radical vision and consummate energy, support and continual advice throughout the editorial process of this book as well as for his contribution in photographing all the objects and posters; to Darrel Couturier, who represented Alberto 'Korda' Díaz during his lifetime and who supported this project from its initial germination to the present: the best of travel companions! To Diana Díaz and the Korda Estate for permission to use *Guerrillero Heroico* and for assisting me in my research in Cuba; to Pedro Meyer, always provocative and thought-provoking, for his generosity and for expanding and globalizing these ideas through his website http://zonezero.com; to Martin Parr and Francois Hebel who helped realize the early part of this project in taking it to the Rencontres Festival in Arles in 2004 with composer Manuel Rocha Iturbide, Mexico; to Centro de la Imagen in Mexico City, and in particular to Gustavo Prado for his support and vison. At ICP I am grateful to Kristin Lubben, an outstanding curator whose mind is as sharp as a knife, the best editor and collaborator one could have, and to Laura Diamond. Thanks go also to Hannah Charlton and Brian Wallis for their contributions, and to Rogelio Villareal for his refreshing and honest anarchy.

I am deeply indebted to Nick Bell, our designer, for more than just 'getting it'; for his patience, wisdom and ability to overcome the many hurdles of long-distance design. To Chris Boot, who listened and gave me good advice at all hours of the day and night. At the V&A Museum, to Mark Haworth-Booth who taught me there is a novel in every photograph, and for supporting this project before leaving the Museum; to Susan McCormack for taking on the show before going on maternity leave and to her colleagues in the Contemporary Department, in particular Lauren Parker and Zoe Whitley, for their kindness. To Mary Butler and Ariane Bankes and their colleagues in the publications department for making this book possible.

My thanks to all the lenders, among them Carol Wells and the Center for the Study of Political Graphics, Los Angeles for her extraordinary generosity in loaning so many magnificent archival posters from their collection; Robert Pledge and Dominque Deschavanne at Contact Press Images; Magnum Photos; the Institut voor Sociale Geschiedenis, Amsterdam; Urbanmedium; Gallery 106, Austin; and Max Ziff for allowing me to keep his *Guerrillero Heroico* off his own wall for so long.

Particular thanks to all the contributing photographers, artists, poster makers and filmmakers who generously have given their time and enthusiasm, and entrusted us with their work.

Photographers and artists: Abbas; Yolanda Andrade; Marcelo Brodsky; Dante Busquets; René Burri; Brian Doan; Jordi Dulsat; José Figueroa; Diego Goldberg; Shifra Goldman; Jonathan Green; John R. Harris; Carol Hayman; Thomas Hoepker; Carl de Keyzer; Barry Lewis; Annie Leibovitz; Pedro Lobo; Marcos López; Raúl Martinez; Francisco Mata Rosas; Douglas McCulloh; Fernando Montiel Klint; Pedro Meyer; Vik Muñiz; Raúl Ortega; Rubén Ortiz Torres; Martin Parr; James Pigoff; Steve Pyke; Ernesto Ramírez; Alessandro Rossi; José Antonio Salas; Larry Towell; Shana Wittenwyler; Zhao Hai Yun; and all the other photographers whom space does not allow us to include.

Poster makers: Raúl Arellano; Felix Beltrán; Roman Cieslewicz; Frémez (José Gómez Fresquet); Jim Fitzpatrick; Jesús Forján; Daysi García; Rupert Garcia; Tran Huu Chat; Patricia Israel and Alberto Pérez; Frank Kozik; Rafael López Castro/Gabriela Rodriguez; Gerard Malanga after Warhol; Ngô Ba' Tháo; Niko (Antonio Pérez González); Alfredo Rostgaard; Elana Serrano; Patrick Thomas. Sadly we were unable to acknowledge the author-artists who made many of the posters included in this book, despite our best endeavours, and we apologize to those whose names are not included.

Grateful thanks to all my friends who personally supported me with this project over the last three years with their enthusiasm as well as practical help: Elaine Brotherton; Nicolasa Hernandez; Mar Verdura; Patricia Mendoza; Fernando Montiel Klint; Steve Pyke; Cinda Rosenberg; Alejandro Springall and Diego Zaragosa.

To my sister Jan Ziff and my mother Ann Rachlin; and to Susan Chapman and the Anglo Mexican Foundation for their financial support.

To my friend Susan Meiselas, whose way of seeing is always an inspiration.

Trisha Ziff
November 2005